Susan Bennerstrom

Essays by

Robin Updike

Rod Slemmons

Sarah Clark-Langager

Davidson Galleries
Seattle

In Association with the
University of Washington Press
Seattle and London

This catalogue has been published
in conjunction with Davidson Galleries,
Seattle, Washington

Distributed by University of Washington Press
Post Office Box 50096
Seattle, Washington 98145-5096
www.washington.edu/uwpress/

ISBN 0-295-97988-7
Library of Congress Card Number
00-102837

SUSAN BENNERSTROM:
THE SHADOWS BEHIND THE LIGHT

A painting by Susan Bennerstrom is, at first glance, a tone poem of easily recognizable elements. Her landscapes are formal compositions of crenellated mountains and precisely tilled fields, solitary stands of oak trees, houses so neat and trim and boxy they could be a child's vision of a fairy tale dwelling. Her still lifes and interiors are quiet studies of simple props, a milk carton on a kitchen table, a man's hat on a stool, a staircase coiling like a nautilus shell, an unmade bed.

Bennerstrom's consummate skill at draftsmanship and rendering makes every object instantly familiar. A mountain is most definitely a mountain. A hat is a hat.

Yet gaze a bit longer at a Bennerstrom composition and you soon realize that what seemed so obvious – a sunstroked landscape, a serene interior – is not so obvious after all. Her realistically rendered works are explorations of abstract psychological worlds.

The landscapes and cityscapes have a mysterious melancholy. The interior still lifes are pregnant with portent. The single light coming from an otherwise darkened house in the nighttime row of houses in *The Fiddler's Room*, 1998 [Plate 57], is not cheery so much as strange. What happened to everyone in this twilight zone of darkness? Similarly the milk carton balanced on the window sill in *Imbalance*, 1999 [Plate 55], seems a symbol of comfortable domesticity and life-affirming nurture, except that this carton is precariously balanced. It may fall at any moment, dropping to the floor in a swift plunge. Like life itself, the carton that looks so sturdy exists in a fragile balance.

Bennerstrom's earliest professional works were lush, watery landscapes of Western Washington, where she was born and has spent most of her life, and the golden wheat fields of Eastern Washington, where she has often visited. Her ability to communicate a sense of place in these images of grain elevators and farmhouses has made these paintings part of the visual vernacular of the region.

Hers are rich, voluptuous, Thomas Hart Benton fields without his robust farmers. Her lonely houses in the valley may suggest the warm hearth of home or they may hint at the lonely seclusion found in the work of Edward Hopper. More recent travels have taken Bennerstrom to Ireland, Mexico, Greece and Italy, where she continues to describe the unique geographies and spirit of each country, though

her clues about place have become more subtle. They are whispered rather than spoken.

Instead of telltale grain elevators and Washington farmhouses, she telegraphs the spirit of Italy or Greece through architectural details – an arched doorway or a terrazzo floor – or the dazzling slant of the Mediterranean light. In *Stone Steps,* 1995 [Plate 21], the languorous light on the red and white floor and stone steps is both seductively beautiful and hard-edged. It is an insistent white light thrusting itself into a passage that leads we know not where. The painting is about the timeless beauty, balance and harmony of the architecture, but also about the unknown. There is a risk in the shadow that falls over the steps. Climbing those steps means walking in the shadow. As with many of Bennerstrom's works, this painting suggests the possibility of danger, the tension of the unexpected.

Over the years, Bennerstrom's images have moved from the broad physicality of the out of doors to the private drama of the interior. Though she still paints images that technically are outside, such as the enigmatic *Regatta,* 1999 [Plate 67], her point of view these days more often is focussed on the corner of a bedroom, the fall of a curtain. These paintings are frequently about relationships between people or the ambiguous moments of everyday life. Moments that are at the same time pleasurable and fraught with danger or sorrow.

In *Delicious,* 1999 [Plate 51], a green apple and a paring knife lie provocatively on a red tablecloth. Both are near the edge. They could easily fall off before the drama of this little coup de grâce unfolds. This is either a modest still life or the image of the forbidden fruit ready to be cleaved by the blade. There is a sexual suggestiveness in the plump fruit and the knife ready for the thrust.

Had *Delicious* been painted in the 17th century, it would have been immediately understood as erotic art. As a contemporary painting, *Delicious* hints at the emotional danger in any sexual liaison. It also can be viewed as a description of perpetual frustration. The awkward distance between the knife and the apple could signal that they will forever remain there, close but never touching. Part of the deliciousness of the scene is the anticipation, and Bennerstrom ensures that the anticipation will last indefinitely.

Other works may be read as metaphors about the sexual and psychological relationships between lovers. In *Inside,* 1999 [Plate 45], a man's rubber work boots stand upright and tall next to a Stetson hat resting on its crown. Turned upside down, exposing its plush satin lining, the hat is provocatively feminine despite its masculine origins. Bennerstrom takes care in naming her paintings, and this one

is a double-entendre suggesting both domestic pairing – the owner of these boots and hat is home and inside for the evening – and more sexual possibilities. Likewise *Without a Map,* 1999 [Plate 59] shows the rumpled pillow and mussed sheets of one half of a double bed. The morning light streams through a window turning the pillow and bedclothes into a psychological map of infinite pathways.

People are implied in Bennerstrom's work, though very rarely seen. Someone has just walked out of the bedroom leaving the door ajar. Someone has risen from the bed but has not yet made it up. Someone is about to reach for the precariously balanced milk carton. Bennerstrom has occasionally inserted people into her compositions, but discovered the humans didn't want to cooperate. Their backs were turned to the viewer. Sometimes they fled. Ironically, Bennerstrom's penchant for idealized realism does not include much interest in depicting people. People, with their facial expressions and body language, would give more specific narratives to her scenes. She'd rather her paintings remain part puzzle. She wants them open to multiple interpretations.

Another constant signature is light. In daytime scenes sunlight streams in from doors cracked open and curtains flung aside. In night paintings, moonlight glows like the soft illumination of a gas lamp. Light spreads from incandescent and fluorescent bulbs casting deep shadows behind household objects. In *Three Possible Doorways,* 1996 [Plate 34], moonlight meets the glow from a street lamp to form a surreal, if ominous, luminosity. Bennerstrom uses light to clarify, to illuminate the corners and hidden recesses. She uses light as a metaphor for the need to look closely at the emotional and psychological situations suggested in her paintings despite the risk of being surprised or threatened by what may be revealed.

Bennerstrom's newest work takes her interest in perception further into the realm of the abstract. In paintings including *Regatta,* 1999 [Plate 67] and *Tempo Perso,* 1999 [Plate 66], the objects in the paintings are easily identified, as always, but the juxtapositions are curious.

In *Regatta,* two small boats without sails, motors or oars drift listlessly on a canal surrounded by imposing but ghostly buildings. The shirtsleeved arms of several men lean unexplainably on a red and gold flag draped over an embankment. If this is a race, why aren't the boats under power? And does the flag with its luxurious deep folds conceal something underneath? The men may be busy observing the race, which is pointless, while the more important action, psychological or otherwise, is apparently going on somewhere else.

Bennerstrom's latest paintings refer unmistakably to the early 20th century work of Giorgio de Chirico, whose disquieting juxtapositions and incongruities were meant to provoke thinking about the metaphysical nature of reality. In one painting, she has included a stone bust of the artist himself. In others, she has borrowed some of de Chirico's favorite symbols of paradox.

In her *Tempo Perso,* 1999, [Plate 66] the robed leg and bare, arched foot of a classical Italian statue is running out of the scene as though it has just leapt through a window from the outside. A yellow rubber glove drapes over the window ledge as if dropped in haste by the running statue. This could be a clue in a supernatural murder mystery, a statue that comes to life and loses an incriminating glove. It is just as likely to be an homage to de Chirico's weird but fascinating exploration of reality. De Chirico depicted both the majestic head of a statue and a rubber glove in his famous *Song of Love,* 1914.

Tempo Perso and *Regatta* are also interesting because they hint that Bennerstrom is experimenting with slipping people, or at least representations of them, into her work. In *Regatta* the arms of the men imply their presence. In *Tempo Perso* the leg of the statue and the glove, though themselves inanimate, represent the human form.

Her partial representations of people further heighten the tension and suspense always lurking just beneath the surface of her paintings. She teases us by depicting people in the abstract, yet their actions and motivations remain mysterious. They are so close that we see an arm or a glove, yet never the entire person. This can be seen as a metaphor for the psychological reality of any relationship. Though we may think we 'see' the whole person, a longtime friend, a lover, we never completely understand him or her. We can never 'see' them fully.

Like de Chirico, a master of realistic painting who used his skills to suggest the unreliability of the obvious, Bennerstrom invites us to look behind the surface. Her landscapes, both exterior and interior, are dreams. They are visions of beauty at the same time they suggest illogical, confusing, potentially dangerous situations. A painter of sensuous surfaces and compelling color, her images can also disturb. Bennerstrom wants us to consider the shadows as well as the light, the tension as well as the serenity in everyday moments.

ROBIN UPDIKE
Independent Art Critic

THOUGHTS ON SUSAN BENNERSTROM'S
USE OF PHOTOGRAPHY

I have had the confusing pleasure of watching Susan Bennerstrom take notes for a painting with her camera. Confusing, because as a photographer, I expected her to be interested in what was in front of the camera, in one instance a 17th century aqueduct and small neighborhood square in Oaxaca, Mexico. In fact, however charmed or intrigued by what was in front of the camera at that moment, Bennerstrom would fold it into something quite different later on. The immediate subject would disappear into another invented subject, first through a system of gluing photographic prints together and later by synthesizing these visual experiments into an image for painting. This is a more complicated process than it would seem. A bed from Ireland might be combined with a window from Italy and a peculiar color combination from Mexico or Eastern Washington. For Bennerstrom there are layers of very real travel memories and emotions connected to all of these elements that the viewer could not possibly decipher without further information, but that are available to inform the final painting as peripherally sensed raw material.

Painters have been interested in how the camera can enhance or organize their own vision since the invention of photography in the late 1830s. But, for at least four hundred years before that, artists had been using various forms of the *camera oscura*, a drawing aid that, combined with light sensitive paper, would become, with a few added features, the camera we use today. It had a lens, a means of focus and a ground glass to view the lens image. Bennerstrom's basic process is not much different than many artists before her, most notably Vermeer, Degas, Caillebotte, Vuillard and Bonnard (these two apparently owned a camera in common). Bennerstrom's personal vision is more appropriately discussed in the light of two more recent users of photographic conventions, Edward Hopper and Charles Sheeler, the latter an important photographer as well as painter. Generally, what these artists were most attracted to was not the documentary power or precision rendering ability of the camera, but its distortions and mistakes – under and over exposure, blurred motion, perspectival shifts, and the bonus abstraction of monochrome which at first seemed like a failure. They were also fond of its distractions, such as giving us more detail than we seem to need. None of these people had any difficulty thinking about what they saw before sitting down to paint – they didn't need the camera for that aspect of what they accomplished. Under the best of circumstances, the camera simply provided them with more to think about. In art, more to think about is always better, in spite of Mies Van Der Rohe's worn dictum.

Bennerstrom utilizes this tradition, and augments it in her use of color. Like her contemporary David Hockney, she has noticed that color photography is yet another abstraction since the palette of any given film is only a percentage of the palette of what the eye sees. Colors and hues are not only left out, however, but the camera invents new ones. A painter, of course, can use any color he or she want once the forms have been decided on. But colors in front of the eye, in real-time perception, can determine form, mass, distance, texture. And all of this can, in turn, be revised – usually intensified – by a heightened sense of perception in the viewer, such as we often experience traveling in a strange place. Bennerstrom has relinquished some of her normal inclination to use color to the distortions of the camera (not to mention the highly variable subsequent printing process in the snap shot labs she uses) and has come up with a combined palette between pastels and photographic color coupler dyes.

As her forms become more simplified, leaving large areas for uniform color, the images veer toward the surreal. For *Lunch,* 1998 [Plate 41], she started with a combination of two snap shots of the Galtee Inn Pub in Cahir, Ireland. Removing all of the pictures from the walls and most of the mullions from the windows, she arrived at a simple divided arch between two rooms, inviting transit between two inviting spaces drenched in light. I suspect that the alarming yellow of the walls was what caused the camera to come out of her bag in the first place, or perhaps the dark arch and wainscoting creating the invitation in an interesting way. She added a white table cloth to pull the eye in, and enhanced raking shadows from the windows, barely visible in the photographs. I also suspect that the orange/red lower shades on the windows are from memory, not photography. Bennerstrom later used these same colors in *Imbalance,* 1999 [Plate 55], a painting of a milk carton based on a black and white photo. The tonal latitude of color print film is notoriously narrow – her eye would not have forgotten that strange color combination. "Memory knows before knowing remembers," in Faulkner's phrase. The camera coldly knows certain things, and the eye feeds the memory whether it is hungry or not – the overlap between these two is what is interesting to Bennerstrom.

The camera, as much as photographers would like to think otherwise, is not particularly dexterous formally. It is much better at interpreting form in terms of chaos, like a good jazz solo, as Lee Friedlander discovered long ago. It really can't invent balance, resolution or even symmetry on its own. *Imbalance* is a good example of how a basic visual problem of whether the milk carton has enough of the shelf to keep it from spilling, can be made into an intricate visual impossibility, and then a metaphoric possibility. By simplifying the shapes and de-emphasizing the transparency and reflective power of the window, Bennerstrom allows us to think the improbable – that the reflection of the carton pulls it into stability, into balance. The core structure of this picture is surreal in that it invites us to invent

a new set of physical laws based on what we see rather than what we know to be true.

One thing photography *is* good at, especially when used as a sketching device, is to very precisely record a point of view. We are always aware of the plane at which its replication of perception stops. We see this as a point, but in fact it is a plane. Usually we ignore this aspect of photography until the plane transects normal, level vision at a peculiar angle. In some of Bennerstrom's recent paintings, the plane is tipped radically down. Normally we don't retain strong visual memories of looking down, for example, to check our path or find something lost, however valuable and interesting this angle might be metaphorically. The camera seems to enjoy exposing poetic laziness. *Inside,* 1998 [Plate 45] derived from a downward aimed snap shot, is a good example. The boots and hat, ready to go, seem to invite a departure from inside the house to outside. The simplicity of the image suggests that we could extend this departure from a safe emotional interior to an uncertain exterior exposure. The upside down hat, aimed at the head from the floor, amplifies this possibility. In another painting, *Stetson,* 1998 [Plate 44], we see this same hat firmly right side up on a table, more suggestive of a firm arrival – a visit.

A painting that reveals the flexibility of Bennerstrom's use of photographs is *Immersion,* 1998 [Plate 48]. The snap shot source for this image was made at Shark Reef Ranch, and is, to a photographer's eye, really interesting. Afternoon sun blasts through a window past a candle and a kerosene lamp and comes to rest in an empty, white bathtub. The view is down at a fairly steep angle, as if from a person entering the tub. In the finished painting, Bennerstrom eliminates almost everything except for the tub and its glowing load of light, and considerably lessens the angle of view to one of observation rather than imminent participation, adding, along with the absence of water in the tub, a nice ambiguity to the title. Changing this angle is no mean feat, which indicates that the photographic "source" is not a substitute for either drawing skill or invention.

Which opens an additional arena for using photographs as assistants to painting. Artists in any media interrupt the flow of perception to make one point or another – sometimes to simply communicate what they have identified as beauty, but usually more. Painting from a remembered pause in observation, or even from a quick pencil sketch on the spot, takes into account that memories are highly susceptible to revision, even seconds later. Visual memories are also highly fragmented – they must be, since the flow of perception is so numbingly dense and relentless. The camera doesn't have these handicaps. Obviously the angle of vision and the selection of the moment of exposure eliminate a lot. But a very large percentage of what hits the film was actually there without question, and stays

there unaltered by time. When an artist like Bennerstrom returns to a photograph she has taken previously, with her new conceptual context for its cold moment, all kinds of extra possibilities for reflection and poetry are raised that have less to do with facts in front of the camera and more to do with provisional disclosure of what she has come to understand about those facts in the meantime, or even about herself. The intersection of memory and perception is not usually so plainly visible, nor the opportunity for reflection so available. This arena is a good place to begin understanding what is behind Bennerstrom's work.

ROD SLEMMONS
School of Art and Graduate Museum Studies
University of Washington

THE ITALIAN PERIOD

A Context

In the late eighties and early nineties when Susan Bennerstrom's pastel paintings were first being appraised in the Pacific Northwest media, critics associated her works with earlier American artists. For example, Ron Glowen stated that her landscapes recalled the curvilinear, agricultural motifs of Thomas Hart Benton and Grant Wood and contained the highlighted, abstract forms of Georgia O'Keeffe and Arthur Dove. A year later, Carmi Weingrod recollected the close-ups of industrial buildings by Charles Sheeler and Charles Demuth and the lonely cityscapes of Edward Hopper. Throughout the early nineties, Karen Mathieson, Sheila Farr and Robin Updike continued to recite the list of American artists of the twenties and thirties. Finally, in 1996 Ted Lindberg hit another chord when he observed some stylistic similarities with the dreamscapes of early Italian modernists, Giorgio de Chirico and Giorgio Morandi.[1] Even after admitting that all of these artists might be her favorites, why would Bennerstrom, an artist emerging in the eighties, be interested in the period of the twenties and thirties?

Besides the flexibility of her medium of pastel, there are several overlapping conditions which give Bennerstrom permission or freedom to roam through time. By the early eighties, American artists had challenged the dominance of abstraction with an openness to both traditional and modernist styles. Their work often resulted in a package of stylistic associations. Turning over earlier periods of American art, artists similar to Bennerstrom discovered ". . . there was a big, untaught, relatively uncelebrated history of American landscape painting lurking in [their] art historical background."[2] Likewise, art historians began to revise their opinions on such periods as American art between the two world wars. For example, the simplest view of the twenties and thirties had been that artists had returned to a native realism after a period of European inspired avant-garde activity. New studies have shown that there was a great diversity of interests: American Scene painting of rural and urban themes including social realism; a continuation of traditional studio painting; a reassessment of avant-garde movements, one avenue being new geometric and expressionist abstractions; and a subjectivist art, including surrealist influences from a precursor such as De Chirico. In general, it was a time for considering the deeper feeling of the masses and a search for order, and a time for giving form to private dreams and the expression of the enigmatic in life.[3]

Despite great economic and social shifts in American society, shades of that recent characterization of the twenties and thirties can be felt in the art of the eighties. Sociological issues, now of a post-industrial nation, and their psychological effects eclipsed such previous concerns as novel advances within an artistic medium and progressive development of form and technology. Two tendencies predominated: first, there was an art oriented to the masses in the sense that photo-based works and an array of commercial objects and their logos were used to convey messages about the encompassing power of media and commodities ordering our lives. Secondly, there was a reinvigoration of the medium of painting whereby artists turned inward to their private visions and experiences. Whether artists deconstructed society through photography and other mechanical media or painted the politics of the personal in their public/private lives, the postmodernist artist stressed a particular, not an universal, narrative.

Typical of this outlook was Eric Fischl's statement for "Expressionism Today: An Artists' Symposium" in a 1982 issue of Art in America: "... I think what's going on today in painting now is coming out of our national identities. People have withdrawn into their own histories to try to find meanings. . . . When Italians and Germans go back into their history, they're going back to their strengths. A lot of American art is going back to sources, too . . ."[4] Fischl went on to mention O'Keeffe and Dove. While critics can still reference these American artists in looking at Bennerstrom's early work, it is those Italians, in fact, who come to play a bigger role in her later work. Bennerstrom's first trip to Italy had been in 1970, followed by a trip in 1986. She would return twice to Italy in the nineties.

For a moment, imagine Bennerstrom, the library clerk and the artist just beginning her pastels, perusing the latest art magazines. Of interest might have been the 1981 Art in America issue devoted to "Realism." Articles ranged from Italian and German politically motivated realism of the twenties and thirties to the solitude of the American Edward Hopper, surveys on contemporary realism, and an interview with Philip Pearlstein. A year later, Bennerstrom might have glimpsed the September headline on Art in America – "Europe '82." Included were some of the Italians – Sandro Chia, Francesco Clemente and Enzo Cucchi – who were shown to be revitalizing their painterly traditions. In a continuing swell of articles on these younger Italians who had hit New York City in 1980, the critics continued to acknowledge their debt to Giorgio de Chirico and his contemporaries (Carlo Carra, Felice Casorati, Giorgio Morandi, etc.) whose work had fused Renaissance spatial techniques with both real and disquieting, dreamlike imagery. Furthermore, the younger Italians' penchant for eclecticism was seen as consistent with De Chirico's elaborate reinvention of his own earlier work, including a return to a type of classicism in the twenties. As Chia would state in a major article in Art

<u>News</u> , " . . . In my opinion, we should work . . . upon this accumulation, this labyrinth of styles."[5] So, what might Bennerstrom funnel together? While using the camera, she would avoid Sheeler's crystallization of photography and painting as well as the strict image transference of the Photo-Realists. Similar to Pearlstein, she would be interested in recording her own visual perceptions, but she also would draw consistently upon a brand of poetic realism found in Hopper's and De Chirico's works. When Bennerstrom has described her own work as possessing "vast stillness, mystery and secretiveness," these threads are, indeed, those of the American master and the Italian master. Both artists were "in the air" from recent retrospective exhibitions as well as highlighted in the aforementioned articles.[6] Moreover, fundamental to an artist as Chia and later to Bennerstrom would be the fact that these Italian metaphysical painters' resources were 14th and 15th century masters, such as Giotto, Piero della Francesca, Mantegna, and Massacio. Whereas Chia's persona as "hero" would identify with this Italian art history, Bennerstrom in her books and travels would come to love the simplicity of their renderings of ordinary objects and architectural environments. Unike Hopper, Bennerstrom would not employ representative social types and scenes but would come to choose images suggesting her life and travels. Her own compositions would point to metaphors about contemporary situations.

The Work

Although Bennerstrom's current work primarily focuses on interiors with still life, we first know her work through landscapes. Moving back and forth across Eastern Washington, the Southwest, Ireland or Italy, she has rendered these country views with a persistent attitude: alternating close and distant views, often with plunging depth via road, river, cliff, ravine or furrow; varying the drama of light and shadow; and refocusing the implied viewer through titles which can be read as simple descriptions of a particular place and time as well as symbolic states of mind, for example; *Holdings,* 1998 [Plate 42] with impending darkness edging towards the farmhouse protected by a shelter belt; *Afternoon of the Big Wind,* 1998 [Plate 43] with windblown and/or fallen trees casting strong shadows across a placid, sunny afternoon at an estate; *Farmhouse at the Edge of Night,* 1996 [Plate 32] with penetrating light on its doorway as the spectral orb moves in the sky. In two seemingly similar landscapes, *Irrigation,* 1996 [Plate 29] and *Obstacles,* 1997 [Plate 37], only subtle details tell the shift in emotional states: ever flowing water in a ditch cutting across endless furrows versus protruding rocks foregrounded in the pooling of the stream moving through waves of grass.

When it comes to the architectural enclosures and still lifes now so prevalent in Bennerstrom's work,

she has a strong preference for near/far as well as inside/outside dichotomies. Between 1992-94, she used architecture and furniture as subjects to draw out characteristics common to the American master Hopper and the Italian master De Chirico. In *Before Breakfast in Portrush,* 1992 [Plate 7], Bennerstrom has taken one of Hopper's unusual viewpoints: here isolating herself in an unseen place which is slightly higher than the observed window and archway belonging to the foregrounded house which is diagonally arranged to close off the full, distant view. In *Folding Chair,* 1994 [Plate 16], she pinpointed Hopper's essential quality of focusing on an architectural space flooded with dramatic light implying some thing or person – here laundry – hidden, distant, beyond the depicted space. While the viewer can speculate about Bennerstrom's interest in De Chirico's sensation of a metaphysical revelation, he/she can actually see where she honed in on one of his devices in *Only Three Legs,* 1994 [Plate 15]. In isolating the blue plastic lawn chair against the rock outcropping, she amplified its shadows so that the chair becomes more unstable and the entire scene more enigmatic. In *Portrush Bathhouse,* 1992 [Plate 12], she confronted the alley between two buildings to create what appears to be a rational space. However, reminiscent of De Chirico, she revealed a foreboding state through sharp foreshortening, strong shadows and an abrupt drop into an awesome horizon. Similarly in *Blood Red Room,* 1994 [Plate 14], it is as if she had zoomed in on one of De Chirico's scenes of empty buildings and arcades which have strong perspectives, sharply tilted planes and mysterious shadows set against a deep space. Continuing into 1995-96, Bennerstrom dwelled on the haunting *Shadow of a Balcony,* 1995 [Plate 22] set against another building and took the total view to a dizzying thrust into space.[7]

In 1995 Bennerstrom also created *Blue Benches* [Plate 23], one of the first works which reveals not only Italy as a place but also her study of those earlier Italian Renaissance masters. In this work Fra Angelico's monks or Madonna and angel seem to have moved out of the San Marco Monastery's cell, literally leaving the door open for the artist.[8] Here, in Italy Bennerstrom discovered the richest inside/outside dichotomy. Although in her earlier work she occasionally had lighted or darkened a doorway or implied a view from a window or balcony, Bennerstrom began to clearly focus on the device of the window: the picture of the landscape in the picture window.

As in *Urbino Open Window,* 1994 [Plate 18] and *Room in Apulia,* 1995 [Plate 25], she centered the Italian landscape inside/outside the window, the former view as the central panel and the latter divided between the real landscape and its mirrored image in the open door. In both pastels the landscape is played against the empty room with bench or bed; in turn, the unseen image of the person/artist is imagined in front of the window/landscape as in typical Renaissance portraits. When she chose the

ruin of the Roman arch to frame the sunset (*Roadside Triumphal Arch,* 1997) [Plate 33], Bennerstrom allowed the spectator to relive the color sensations until he/she is flooded with the realization that, perhaps, the landscape is not Italian, but rather part of her homeland – the American West. This holding on to memories is suggested in *Protection,* 1997 [Plate 38] where the Italian cypresses mark the distant hills, but the arched door/window is partially blocked by a dark panel in front of an unset table. While the image of the table (another type of tableland) is important in Bennerstrom's work, it is the coupling of this vertical panel with the sheets of the bed, as in *Witness,* 1999 [Plate 58], which soon dominates. From the Italian window, Bennerstrom also began to understand the metaphorical connection between the landscape and the bedscape.

In fact, the pairing of the bed and the land was hinted at earlier in *Laundry in a Dry Landscape,* 1996 [Plate 30] where Bennerstrom cropped the view so that the roof line and clothesline are set against the distant mountains; the folds of the bed linens also echo the mountain ridge's patterns. However, in using the metaphor Bennerstrom did not give the viewer the expected transitions. In *Witness,* the central, vertical panel actually sets up a dualism between the empty, but recently occupied bed and the open window with no view. The comparison of *Bed of Memory,* 1998 [Plate 46] and *Alternating Current,* 1998 [Plate 47] helps to clarify the different readings this range of work can provide. Whether Bennerstrom focused on the pillar itself or distanced the bed, the viewer is left with questions: is there a conflict between staying and going; do these scenes refer to places of lovemaking or to the desire for travel and adventure? Finally, compare all three works with *Bedscape,* 1999 [Plate 52]: the viewer is left wondering if the open window with no depicted view in *Witness,* the landscape in the two windows tightly matched with the two pillars on the *Bed of Memory,* and the real open door but reflected window pattern on the wall and bed of *Bedscape* all imply a different narrative concerning the absent artist in her studio absorbing both real and imagined landscapes.

As if returning to the table behind the panel blocking the landscape in *Protection,* 1997, Bennerstrom has recently concentrated on still lifes on that horizontal surface. Again, it is in Italy that she discovered this subject in many variations. While she formally framed the table with white tablecloth under the arched cove in *Renaissance Table,* 1994 [Plate 19], she began to play with its metaphorical meanings in the late nineties. In *Milk,* 1997 [Plate 35], she symmetrically placed the yellow milk carton on the red draped table in front of a dark blue panel/window as if she were substituting the arrangement for a Madonna and child before the Venetian landscape. Reminiscent of De Chirico's mysterious use of food paired with maps in his elaborate still lifes, Bennerstrom arranged a closeup of a "red bowl," a leaf, and a fragment of a framed landscape painting on a tilted table[9] [*Red Bowl & Landscape,*] (1998)

[Plate 49]. One year later, the carton or bowl on the table has returned to the folds of the bed covers before an opened window *(Pour,* 1999) [Plate 54]. Whether remembering Italian bed and breakfast reservations, meals, or trips to civic plazas and museums and/or Northwest weather, Bennerstrom in this work has merged the landscape (window or painting), table (still life), and bed into a total image of desire. Varying the inside/outside dichotomy, she again created a series of works evocative of full and/or empty experiences.

In the development of Bennerstrom's recent work, including the still lifes, it is helpful to turn back to the 1981 Art in America issue on realism. In the article on the Beaubourg exhibition of international artists returning to realism in the twenties, Felice Casorati's *Midday,* 1922 is prominently illustrated. In discussing the Italian and German artists as well as mentioning the American Edward Hopper, the author noted the troubling, melancholic spirit of De Chirico's work which frequented some of their sober and volumetric renditions. Casorati's work is described as ". . . somewhere between the quattrocento and the [contemporary] Philip Pearlstein."[10] In this particular work, Casorati has rendered an interior with a high horizon line; looking down on the floor, he has inserted among the nudes a broad brimmed hat, shoes, a pitcher, and window drapery skirting the floor. Until recently, Bennerstrom has not relied on the depiction of the human figure, as did Casorati, to imbue psychological overtones in her landscapes or still life arrangements. But in a group of new works, she has brought the viewer closer to this device in her narratives.

As in Bennerstrom's landscapes, her precise choice of details charges each scene. In *Delicious,* 1999 [Plate 51], she did not draw Eastern Washington's apple groves but rather placed an apple with a peeling knife on a table. If compared with De Chirico's similar still life situated on the floor *(Still Life with Salami,* 1919),[11] Bennerstrom's work is more telling about a domestic relationship. De Chirico's knife points towards a thin, vacant horizon; Bennerstrom's knife, while delicately balanced on the edge of the table, points towards the striped rug at the door. Depending on the viewer's own mind set, the implication of arrival to and departure from this table can have welcoming or threatening overtones. In a few earlier works, Bennerstrom actually heightened the focus on implied action through the introduction of a small human figure. Therefore, with the title *Flesh,* 1999 [Plate 60] the spectator expects more than Bennerstrom gives; here, no glimpse of a figure, rather only the blowing, flesh colored curtain at night reflected in the pane of an open window looking down onto a walk. Since the mid nineties, Bennerstrom has worked with this detail of concealment – the sheet, curtain, or cloth – and has conjured a variety of emotional states: the ghostly configuration of *The White Sheets,* 1995 [Plate 24] appearing high up and between two buildings; the light shining behind the voluminous,

golden drapery dusting the floor in *Scrim,* 1999 [Plate 61]. Of interest has been the changes made in the new work *Tempo Perso,* 1999 [Plate 66] where originally a waving curtain at the window sill of a red room diagonally separated two images: inside, a white statuesque foot emerging from voluminous white cloth; outside, a green space. In the next version, a glove on the window sill replaces the curtain.[12]

Regatta [Plate 67] picks up on these details of human body parts. Almost out of view are three figures nestled together, elbow to elbow, on brilliant gold and red cloths spreading towards the lagoon. In the background a strong light falls across the Italianate architecture and lagoon where two empty rowboats float.[13] In the past Bennerstrom has used the image of the boat, both resting on shore (*Repose* and *Figment,* 1998) [Plates 39 and 56] and floating adrift under an urban bridge (*Lost Boat,* 1996) [Plate 36]. But in *Regatta,* there seems to be a tension between the rewards of the festive occasion - the unfurled banners from the competition – and the striving for mastery – the implied race of the unanchored boats. Along with *Tempo Perso,* Bennerstrom gives a different nuance to the theme of travel or passage in her new work. Just as the boat floats on the river or lagoon without oarsman, 'time' silently moves through our lives. The glove on the window sill is there to delicately handle our 'flesh,' our vulnerable body, the fragility of our full life.

Conclusion

Perhaps, it was those Italians of whom Eric Fischl spoke, who gave Bennerstrom her sense of the passage of time. In Italy she would establish her ties with centuries of art as well as realize the progressive rush of America through the twentieth century. Both she and Fischl would depict subjects using snapshots, artistic references, and psychological symbolism. Responding to culture's stereotypes and cliches, Fischl has created domestic scenes of adolescent and sexual fantasies played out in the movies and television. In contrast, Bennerstrom has concentrated on the private, physical world around her to make ties with the cultural world. Immersed in travel, art, books or the bathtub (*Immersion,* 1998), [Plate 48] she, as other artists of the nineties, has upheld memory as her psychological key. Observant of a wide range of art and experiences, she has provided her own type of order for the depiction of our vast world, often filled with unsettling situations.

SARAH CLARK-LANGAGER

Director, Western Gallery
Western Washington University

END NOTES

1. See bibliography for reviews.

2. Quotation from April Gornik in "Three Painters: Susan Rothenberg, April Gornik, Freya Hansell," Bomb 23, Spring 1988, p. 19.

3. For one view on this period, see: Sarah Clark-Langager, Order and Enigma, American Art Between the Two Wars (Utica, New York: Munson-Williams-Proctor Institute, 1984).

4. Quotation by Fischl in *Expressionism Today: An Artists' Symposium,* Art in America, December 1982, p. 60.

5. For pertinent articles on realism, see September 1981 issue of Art in America: Linda Nochlin, "Return to Order," pp. 75-83, 209, 211; Donald Kuspit, " What's Real in Realism?" pp. 84-95; Gerrit Henry, "Painterly Realism and the Modern Landscape," pp. 112-119; Sanford S. Shaman, "An Interview with Philip Pearlstein," pp. 120-126, 213, 215; Rob Silberman, "Edward Hopper and the Implied Observer," pp. 148-154. For the Art in America article on the Italians, see: Carter Ratcliff, "On Iconography and Some Italians," Art in America, September 1982, pp. 152-159. For other pertinent essays, see: Denys Sutton, "Order and Enigma, Italian Art of the 1920s," Apollo, December 1980, pp. 408-413; Attanasio di Felice, "Painting with a Past," Portfolio, March/April 1982, pp. 94-99; Diane Waldman, Aspects of Italian Art Now (New York: Solomon R. Guggenheim Museum, 1982); and Howard Fox, A New Romanticism. Sixteen Artists from Italy (Washington, D.C.: Hirshhorn Museum and Sculpture Garden, 1985). For Chia's quotation, see: Gerald Marzorati, "The Last Hero," Art News, April 1983, pp. 59-66, quote on p. 60.

6. The Whitney Museum of American Art, New York, mounted a traveling show in 1981-82, "Edward Hopper: The Art and the Artist," with a catalogue by Gail Levin, published by W. W. Norton in association with the Whitney; the show traveled to San Francisco, December 1981-February 1982. William Rubin at The Museum of Modern Art, New York, curated a retrospective on Giorgio de Chirico in 1982; the exhibition catalogue did not focus on the late work of De Chirico.

7. For examples of Hopper's work, see: Gail Levin, Edward Hopper. A Catalogue Raisonne, Vols. I-III (New York: Whitney Museum of American Art in association with W. W. Norton, Inc., 1995). For examples of De Chirico's use of deep space, see: James Thrall Soby, Giorgio de Chirico (New York: The Museum of Modern Art, reprint edition 1966), esp. pp. 226-227, 237. For the late work of De Chirico see: Isabella Far, De Chirico (New York: Harry Abrams, Inc., 1966), pl. 82. Note the interesting comparison of Bennerstrom's *Only Three Legs* and a De Chirico work including rocks and a table.

8. For a history of Italian art in general, see: Ernest T. DeWald, Italian Painting 1200-1600 (New York: Holt, Rinehart and Winston, 1961); for Fra Angelico and San Marco Monastery, pp. 241-254; for Piero della Francesca's Renaissance portraits of Duke and Duchess of Urbino, p. 228; for arches framing landscape views in Renaissance art, such as Botticelli's magi scene, p. 277; for the development of Madonna and child before window ledge, see "The Bellini Brothers and Antonello da Messina in ch. 24.

9. For a typical De Chirico still life, see Soby, pp. 221-222.

10. For a description of Casorati's painting, see Linda Nochlin, p. 75.

11. For De Chirico's *Still Life with Salami,* see Soby, p. 239.

12. One of De Chirico's most famous works was *Song of Love* (1914), a still life including a large surgeon's glove; see Soby, pp. 76. The delicate foot could come from Botticelli's paintings; see *Primavera or The Birth of Venus* in DeWald, p. 278.

13. De Chirico, as well as earlier Italians, also painted the subject of the regatta; see Far, pls. 116, 139, and 164.

Plates

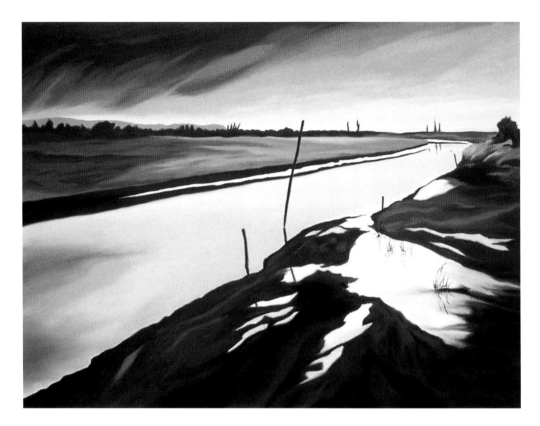

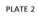
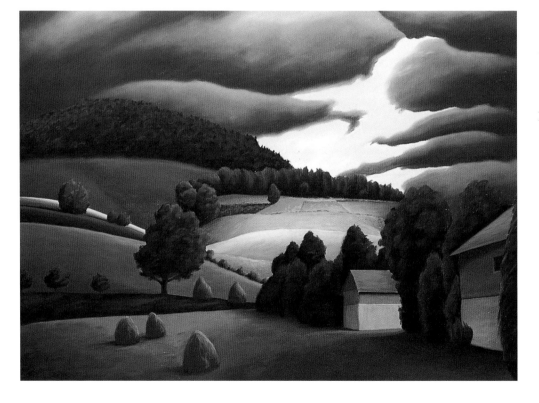

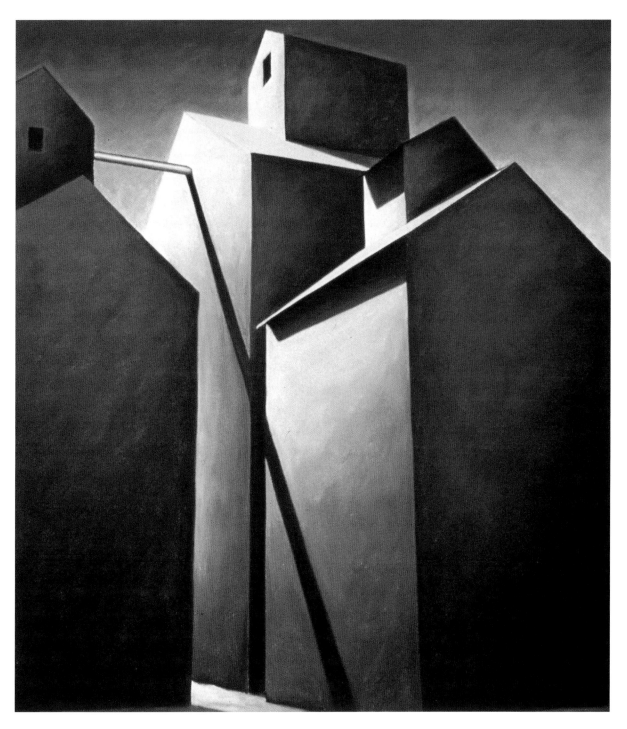

PLATE 3

Crowd of Grain Elevators

1989
Pastel on Paper
22 ⅜" x 20"

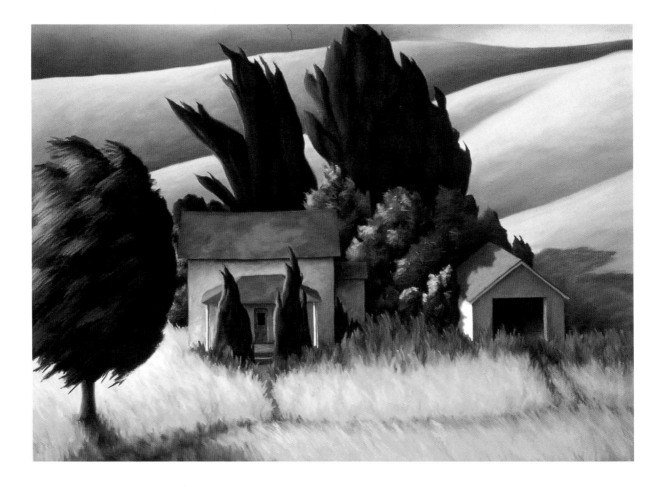

PLATE 4

Wind, Late Afternoon

1990
Pastel on Paper
26 ½" x 36 ½"

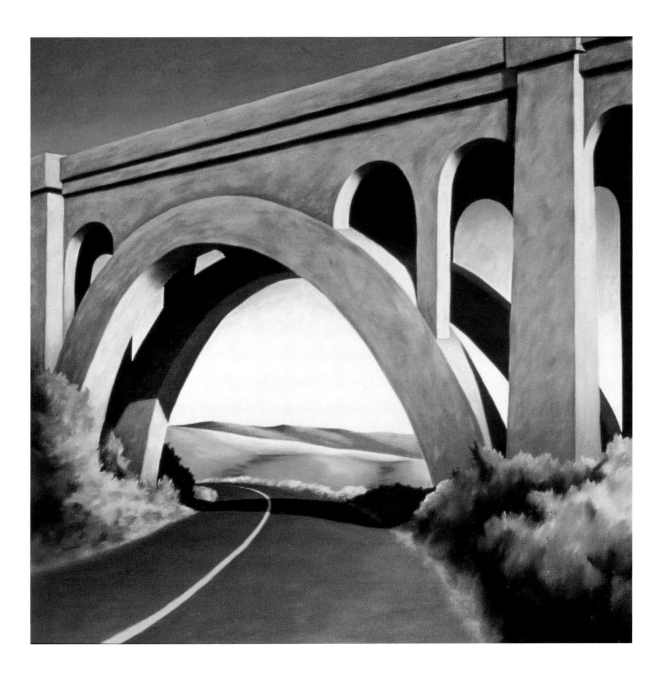

Bridge at Rosalia

1991
Pastel on Paper
26 ½" x 26 ½"

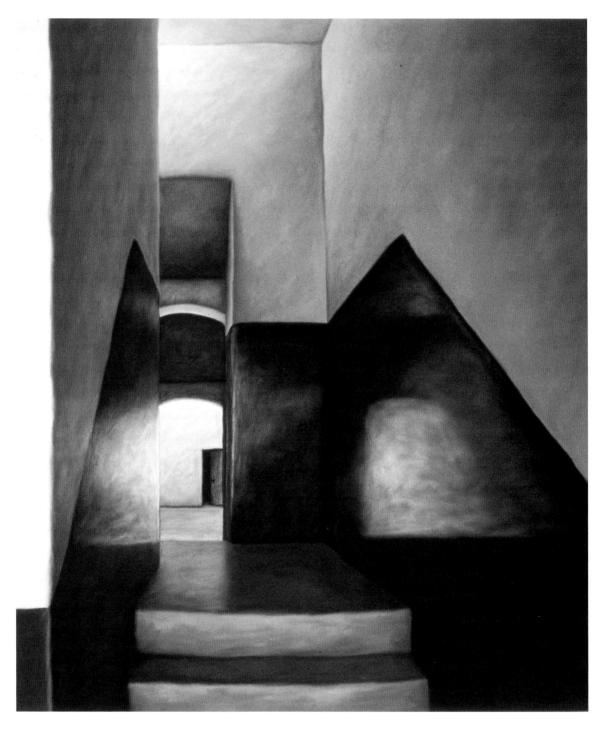

PLATE 6

In Bull Alley

1992
Pastel on Paper
30 ½" x 26 ½"

PLATE 7

*Before Breakfast
in Portrush*

1992
Pastel on Paper
26 ½" x 36 ⅜"

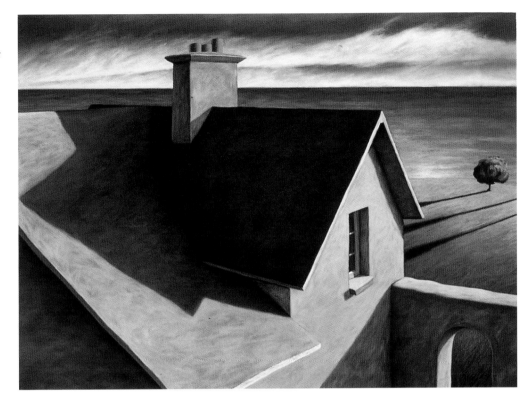

PLATE 8

*Warehouse
District*

1993
Pastel on Paper
26 ½" x 37 ½"

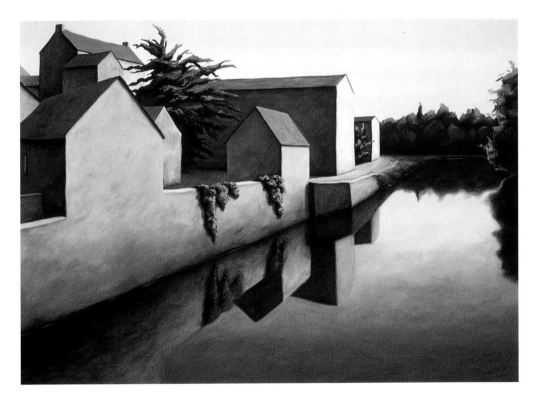

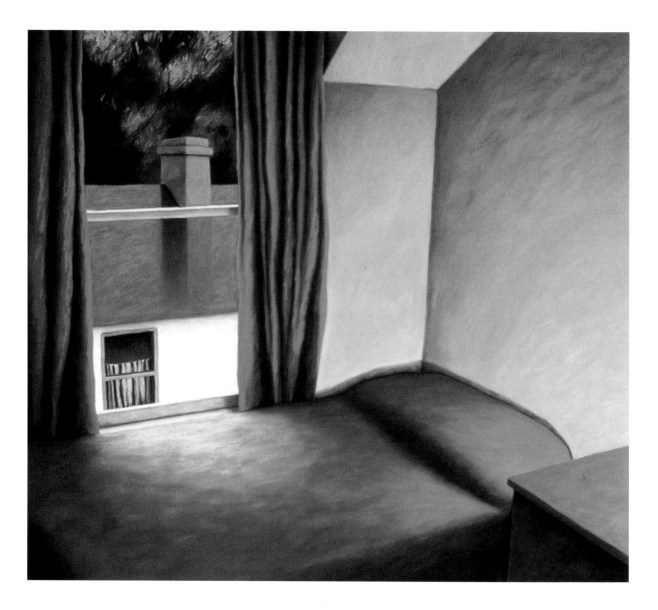

PLATE 9

Purple Bed

1993
Pastel on Paper
26 ½" x 29 ⅞"

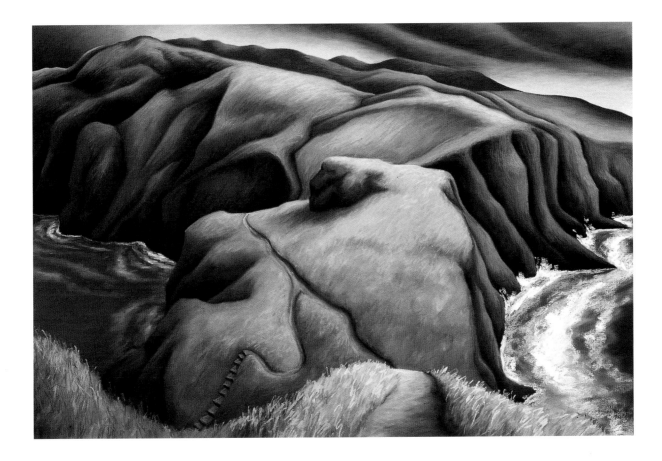

PLATE 10

Coastline

1993
Pastel on Paper
25 ½" x 38"

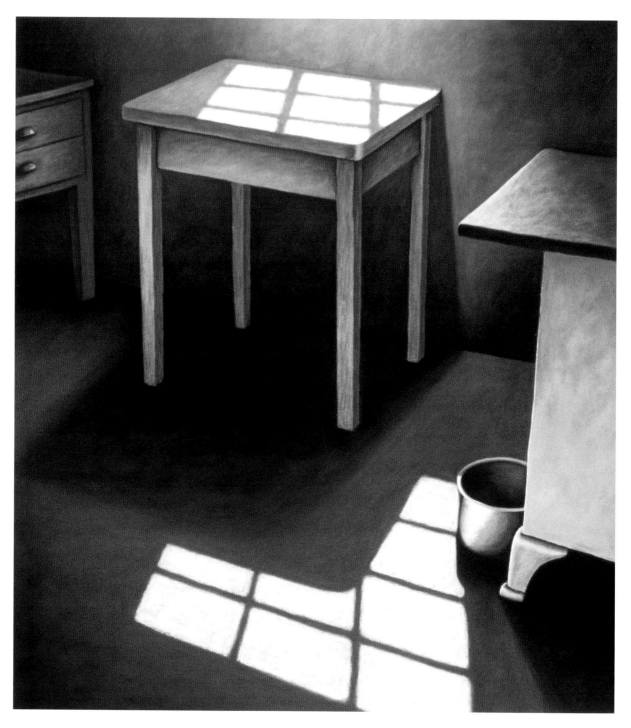

PLATE 11

Green Kitchen Table

1993
Pastel on Paper
29 ⅜" x 26 ½"

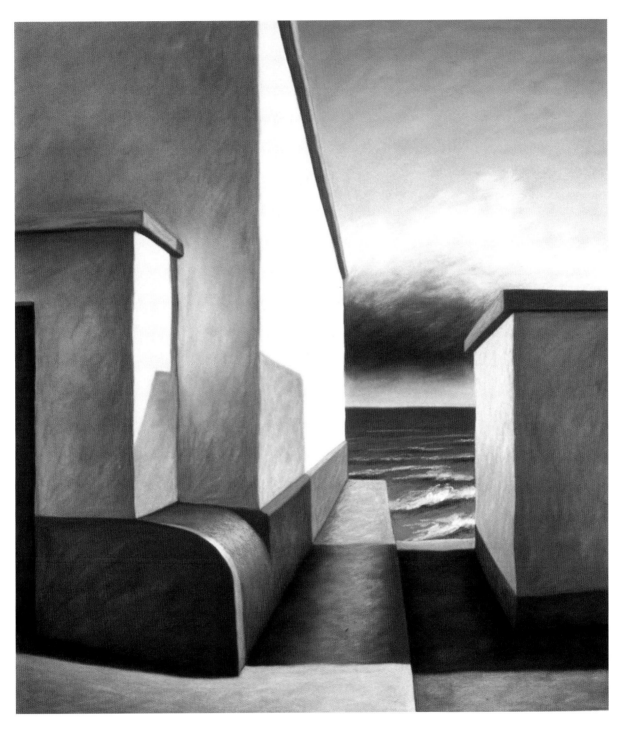

PLATE 12

Portrush Bathouse

1993
Pastel on Paper
29 ¾" x 26 ½"

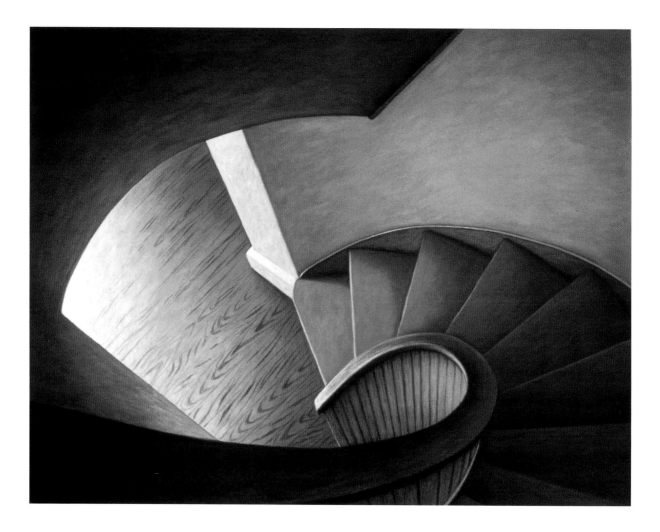

Coil

1994
Pastel on Paper
26 ½" x 34 ½"

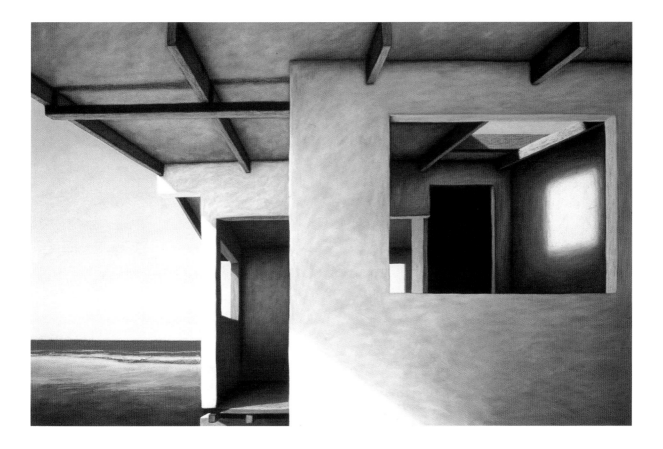

PLATE 14

Blood Red Room

1994
Pastel on Paper
24 ¾" x 38 ¼"

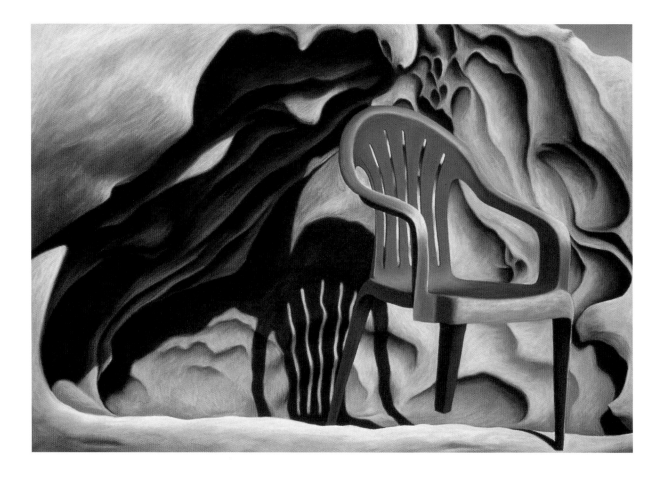

PLATE 15

Only Three Legs

1994
Pastel on Paper
26 ½" x 38 ¼"

PLATE 16

Folding Chair

1994
Pastel on Paper
21 ¾" x 26 ½"

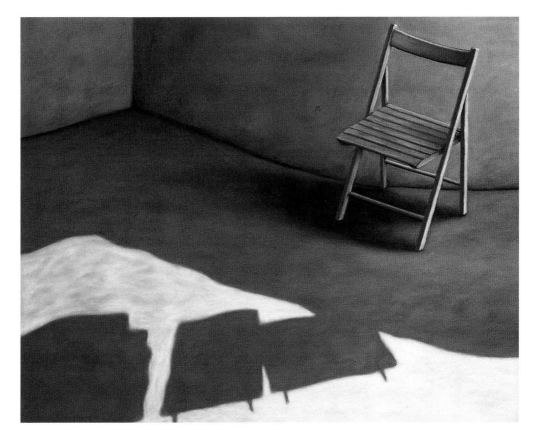

PLATE 17

Mission Chair

1994
Pastel on Paper
26 ½" x 37 ¼"

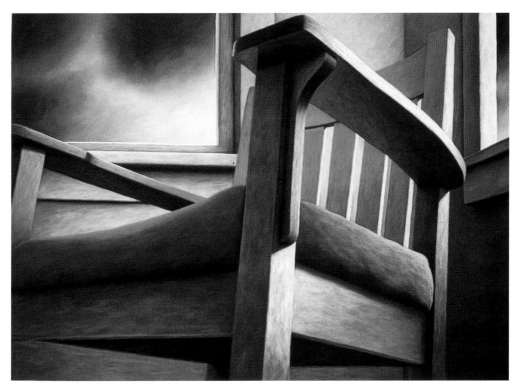

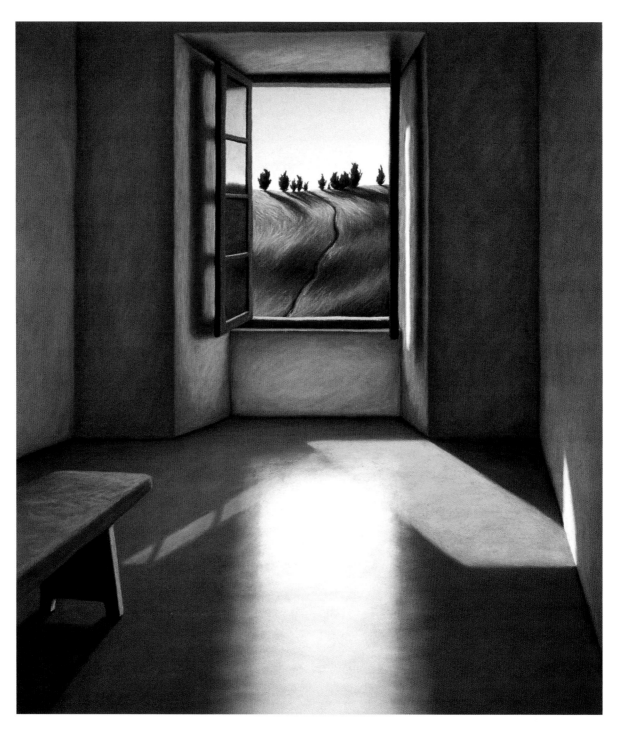

PLATE 18

Urbino Open Window

1994
Pastel on Paper
30 ¼" x 26 ½"

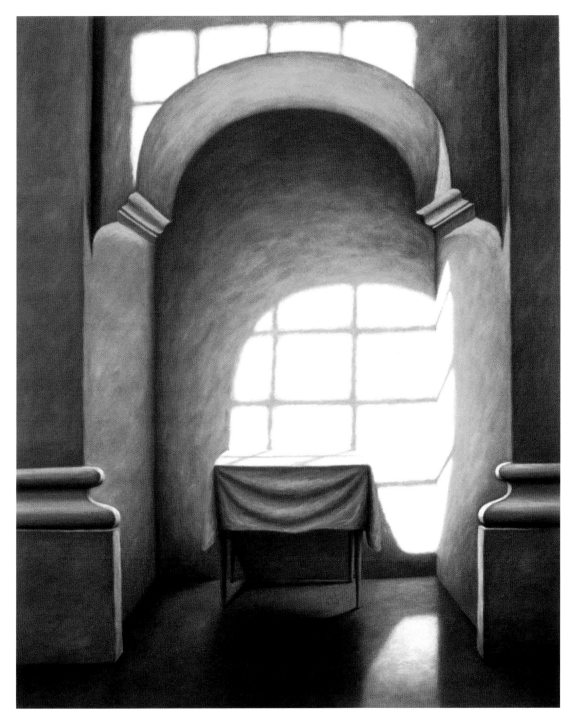

PLATE 19

Renaissance Table

1994
Pastel on Paper
32 ¾" x 26 ½"

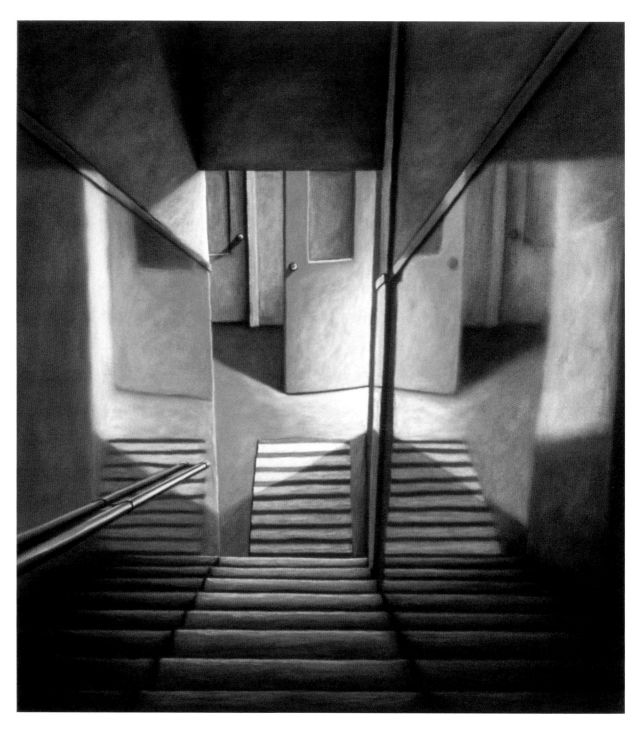

PLATE 20

Shiny Walls

1995
Pastel on Paper
29 ⅛" x 26 ½"

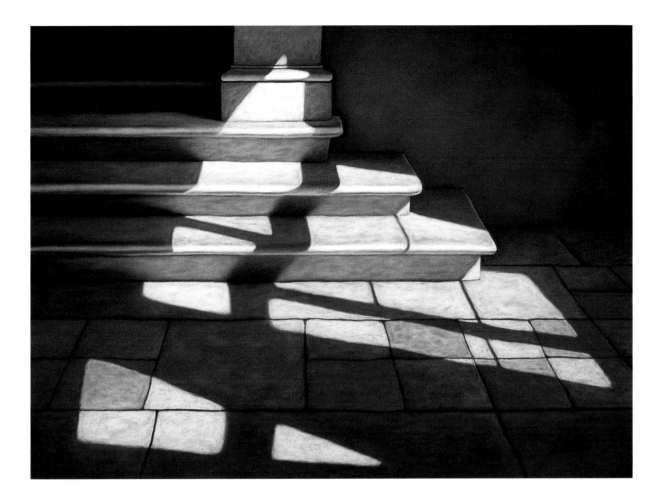

PLATE 21

Stone Steps

1995
Pastel on Paper
26 ½" x 36 ⅜"

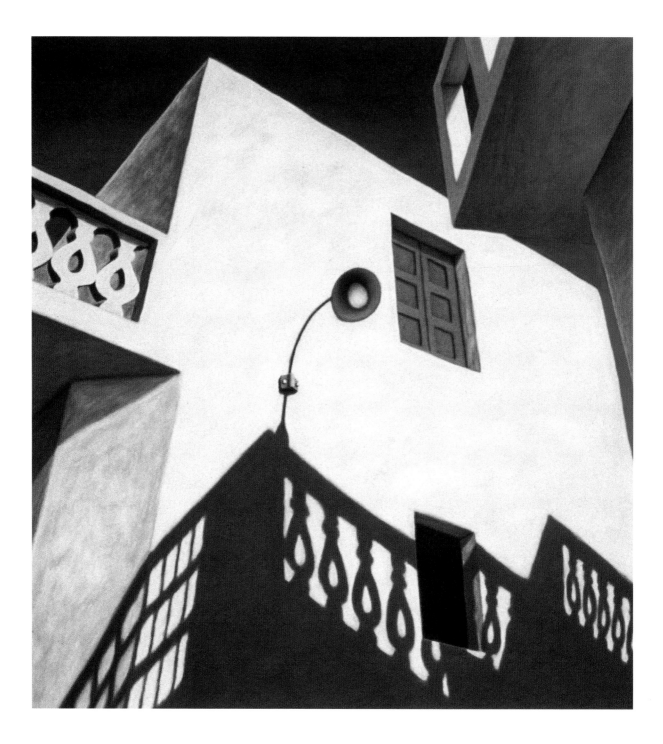

PLATE 22

Shadow of a Balcony

1995
Pastel on Paper
28 ½" x 26 ½"

PLATE 23

Blue Benches

1995
Pastel on Paper
26 ½" x 30 ¾"

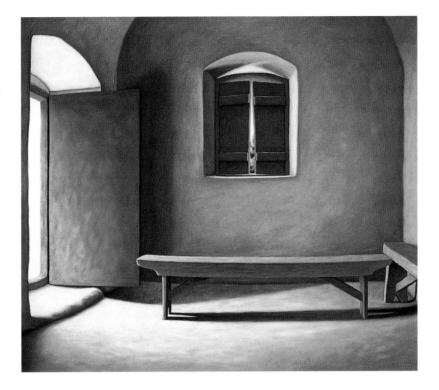

PLATE 24

The White Sheets

1995
Pastel on Paper
26 ½" x 38"

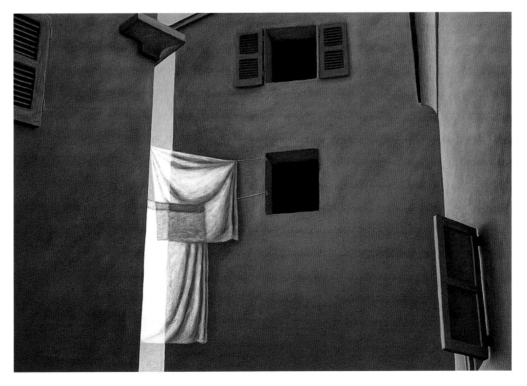

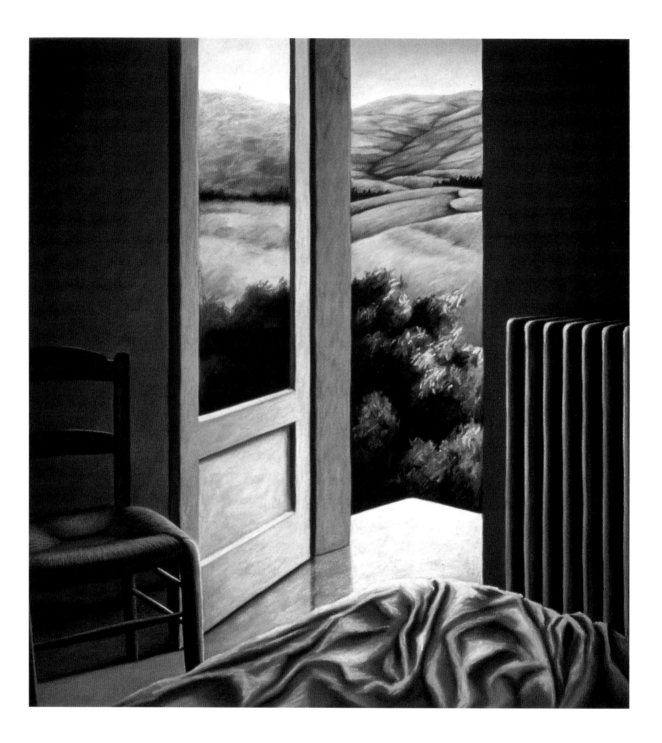

PLATE 25

Room in Apulia

1995
Pastel on Paper
28 ½" x 26 ½"

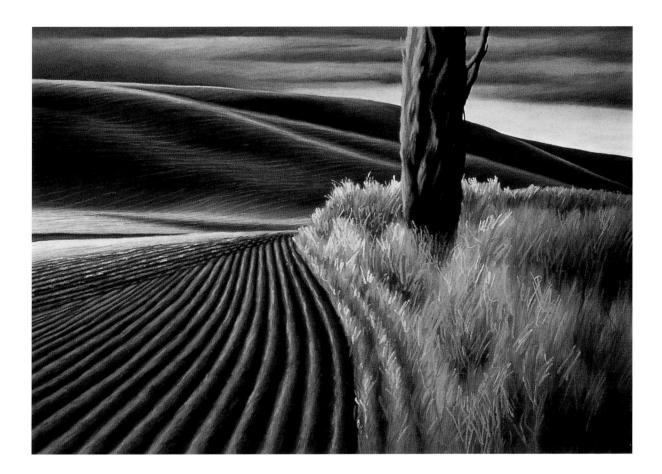

PLATE 26

New Wheat

1995
Pastel on Paper
26 ½" x 38 ½"

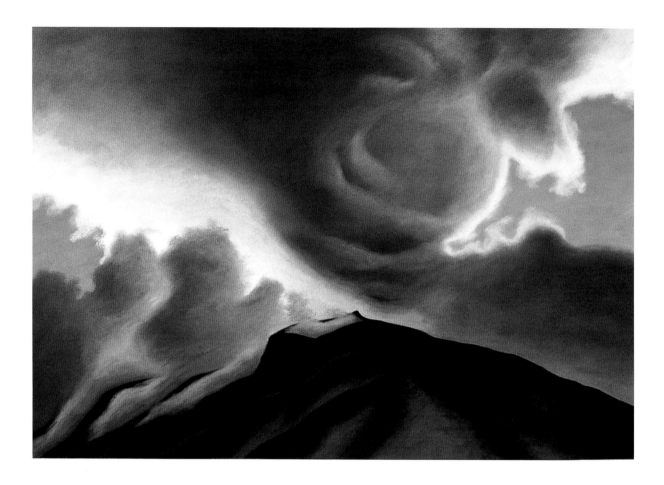

Smoking Mountain

1995
Pastel on Paper
26 ½" x 38 ½"

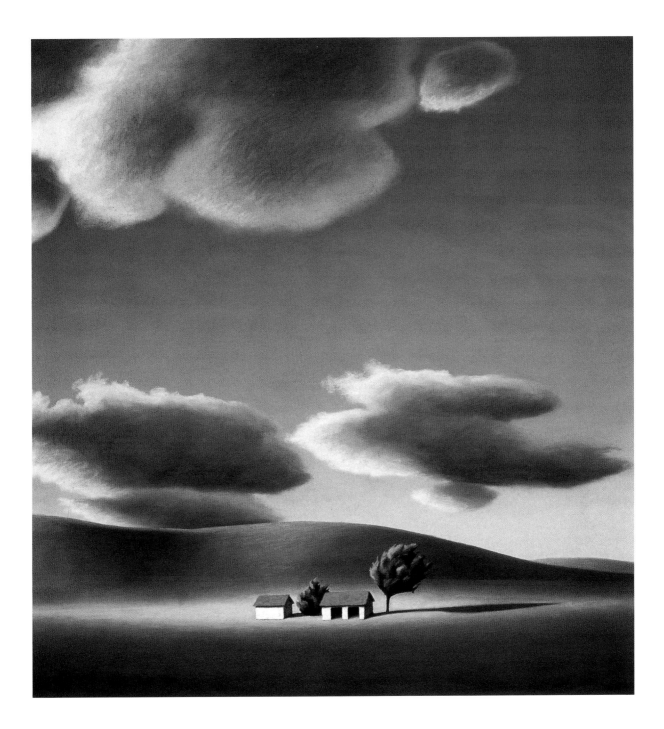

PLATE 28

Small Shelter

1996
Pastel on Paper
27 ⅞" x 26 ½"

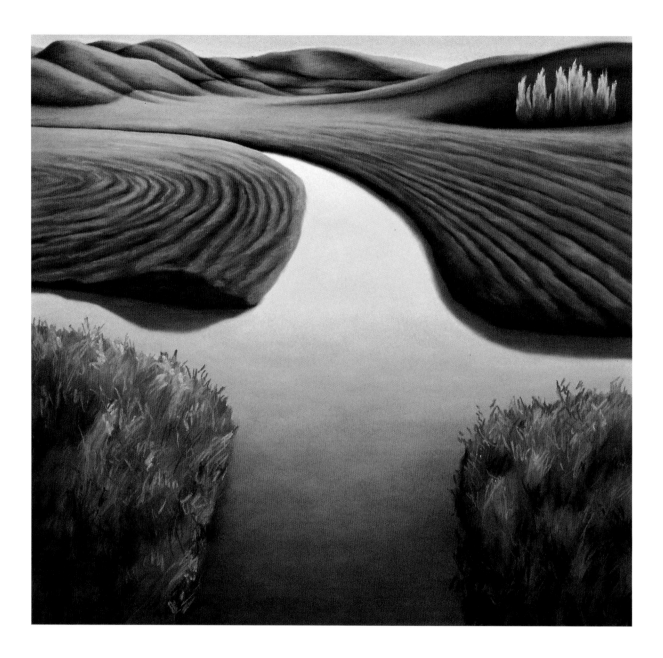

PLATE 29

Irrigation

1996
Pastel on Paper
26 ½" x 27 ¾"

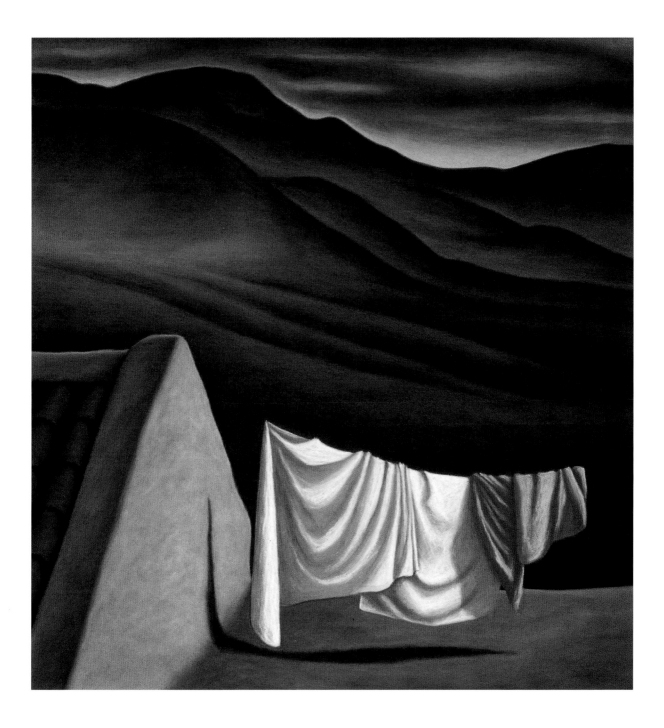

PLATE 30

Laundry in a Dry Landscape

1996
Pastel on Paper
27 ½" x 26 ¼"

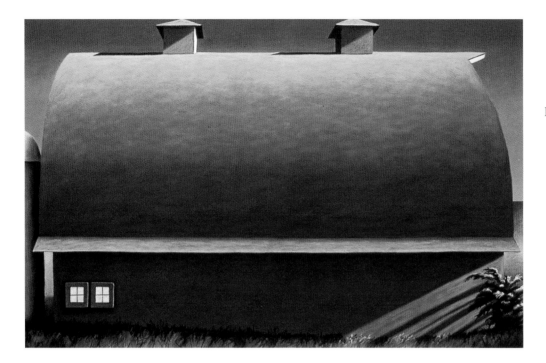

PLATE 31
───────

Sanctuary for Cows

1996
Pastel on Paper
24 ⅜" x 38 ¼"

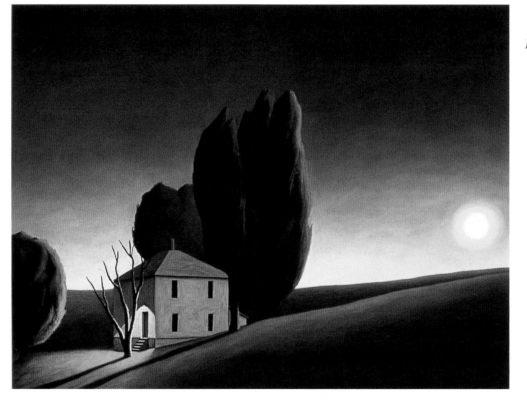

PLATE 32
───────

Farmhouse at the Edge of Night

1996
Pastel on Paper
26 ½" x 35 ⅜"

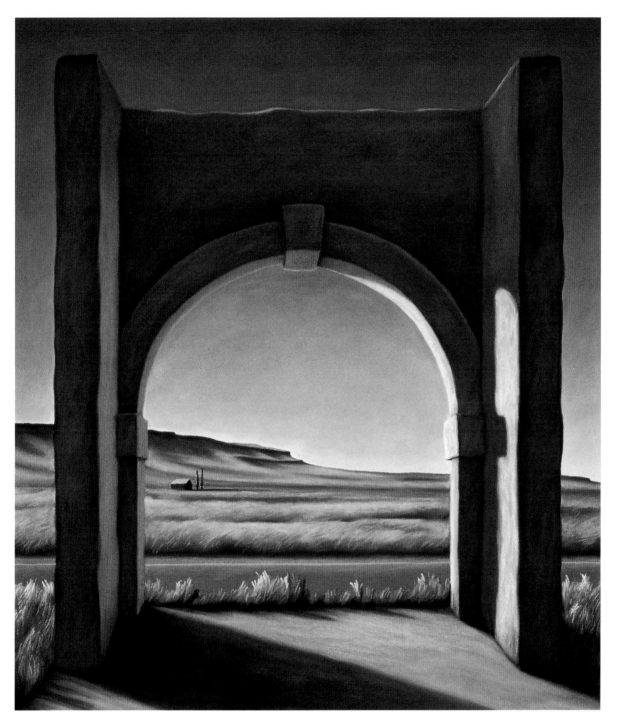

PLATE 33

Roadside Triumphal Arch

1997
Pastel on Paper
26 ½" x 23 ¼"

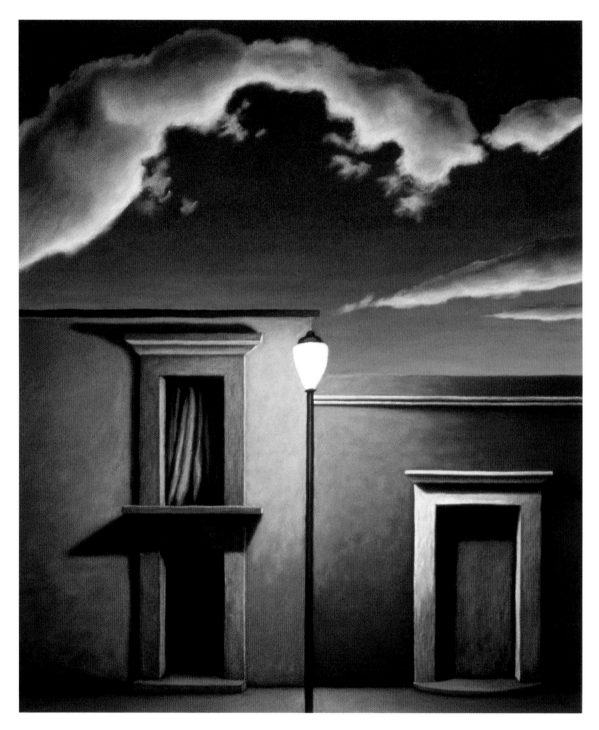

PLATE 34

Three Possible Doorways

1996
Pastel on Paper
31 ⅜" x 26 ½"

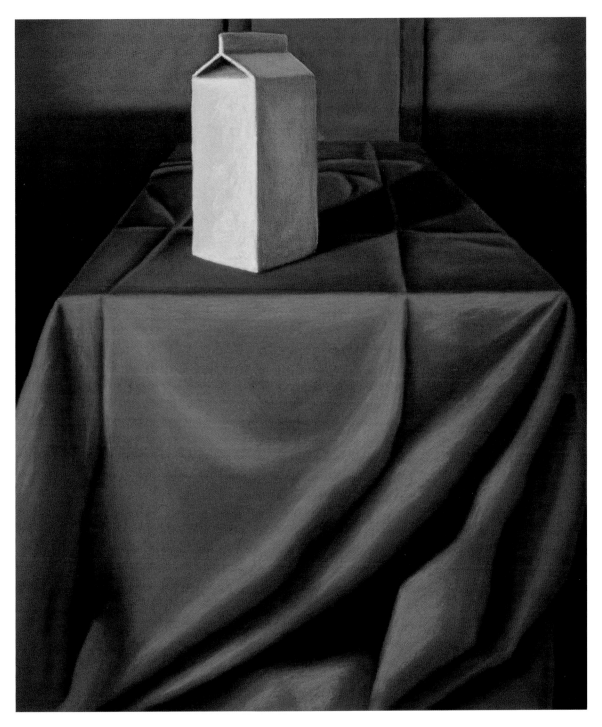

PLATE 35

Milk

1997
Pastel on Paper
17 ½" x 15"

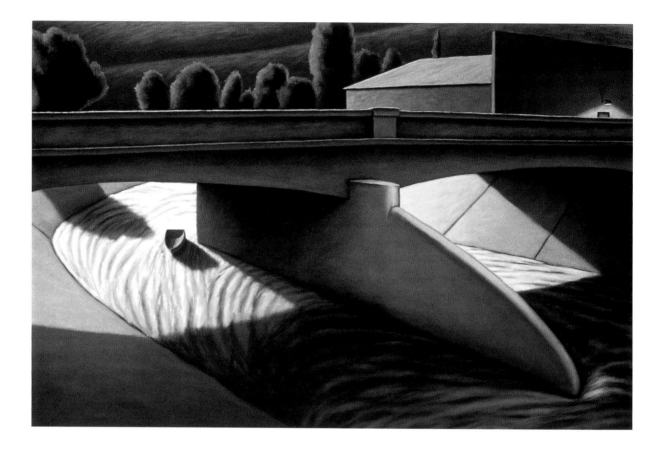

PLATE 36

Lost Boat

1996
Pastel on Paper
25" x 38 ¼"

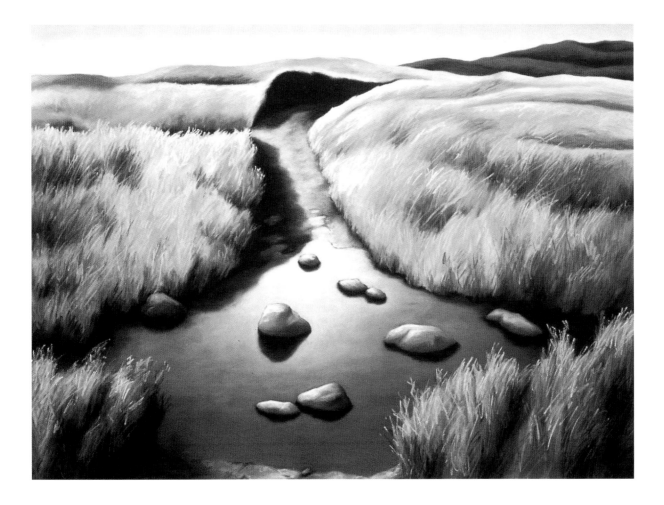

PLATE 37

Obstacles

1997
Pastel on Paper
26 ½" x 36 ⅜"

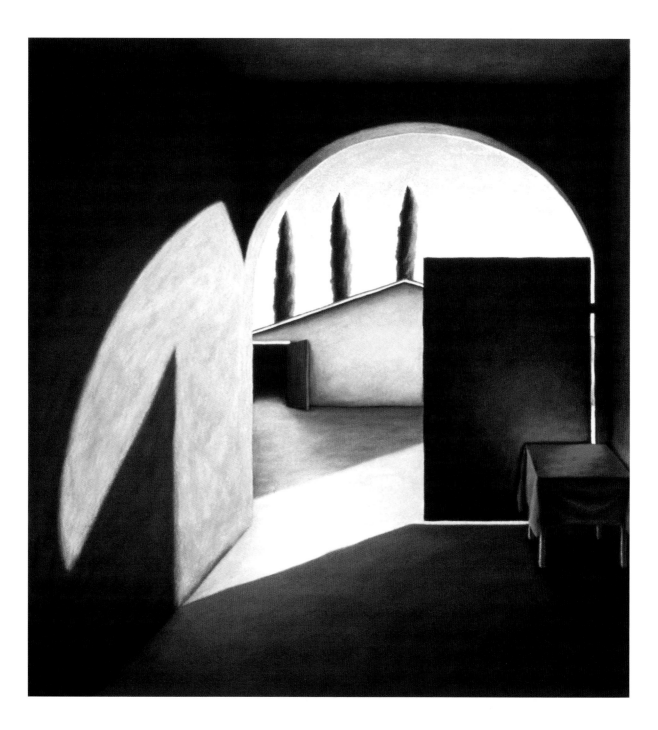

PLATE 38

Protection

1997
Pastel on Paper
28 ⅛" x 26 ½"

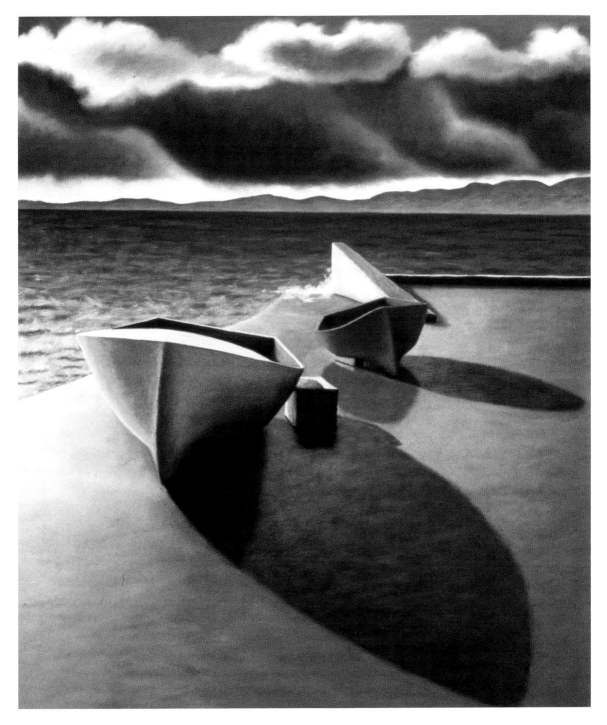

PLATE 39

Repose

1998
Pastel on Paper
30 ⅞" x 26 ½"

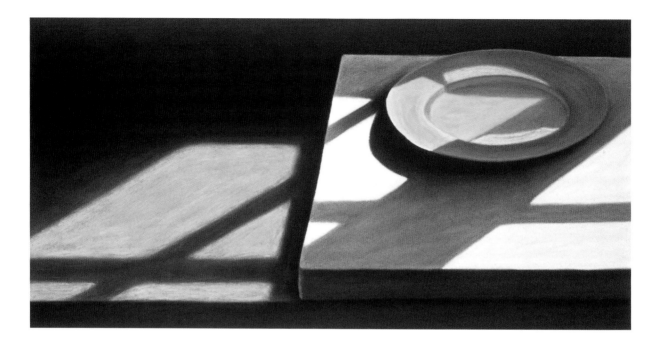

Orange Plate

1997
Pastel on Paper
11" x 22"

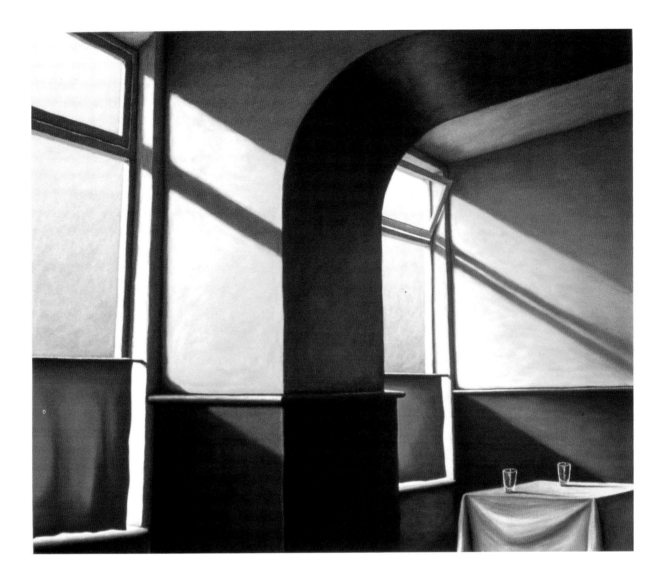

PLATE 41

Lunch

1998
Pastel on Paper
26 ½" x 31 ⅝"

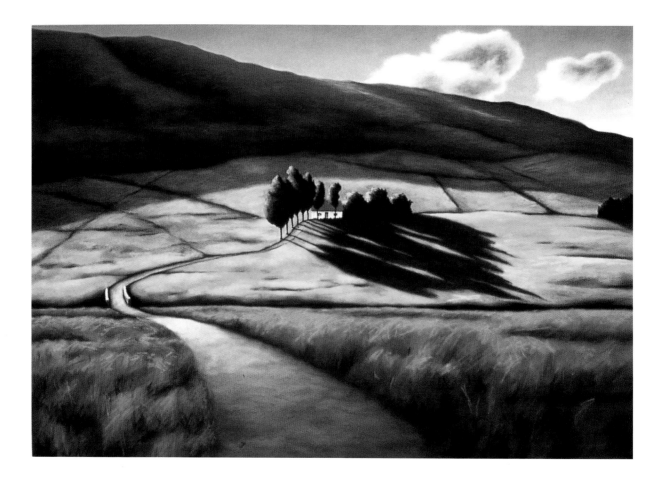

PLATE 42

Holdings

1998
Pastel on Paper
26 ½" x 38"

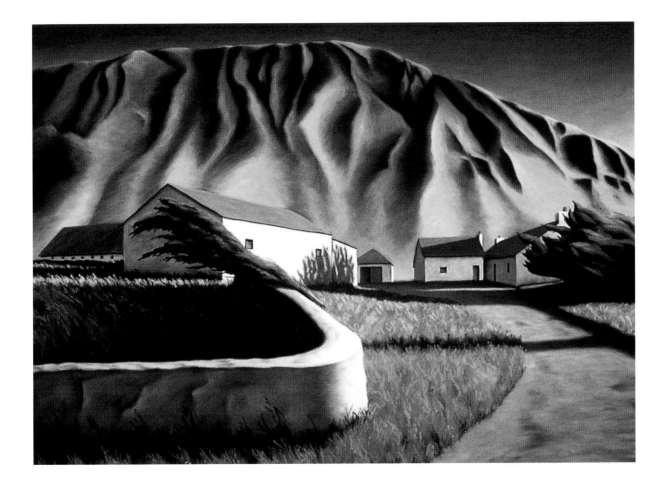

PLATE 43

Afternoon of the Big Wind

1998
Pastel on Paper
26 ½" x 37 ⅜"

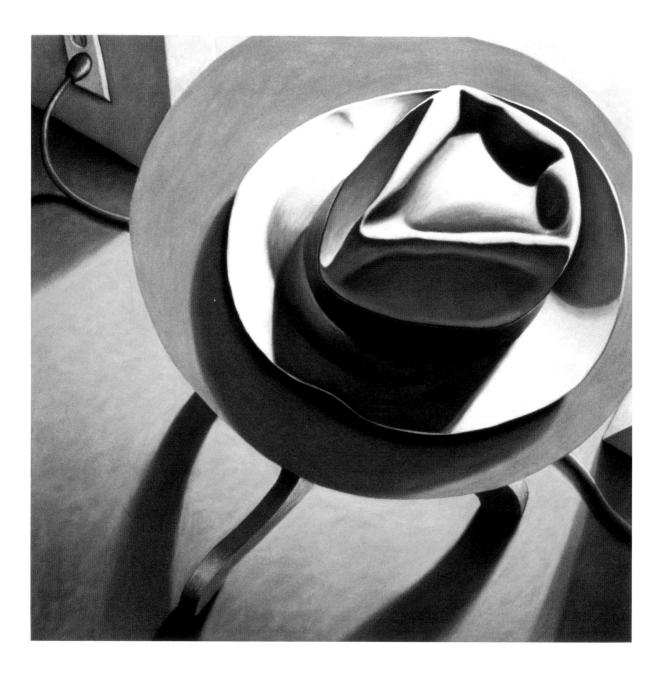

Stetson

1998
Pastel on Paper
26 ½" x 27 ⅜"

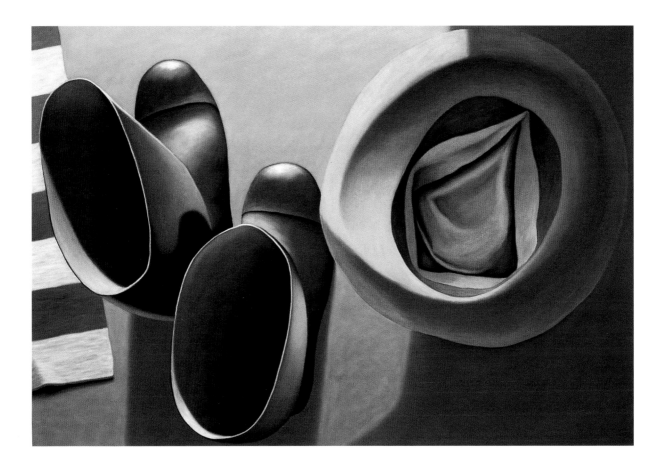

PLATE 45

Inside

1999
Pastel on Paper
26 ½" x 38"

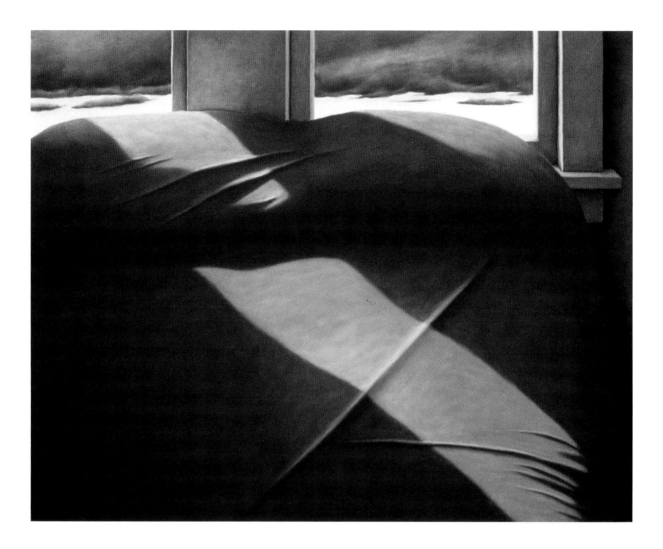

PLATE 46

Bed of Memory

1998
Pastel on Paper
26 ½" x 33 ¾"

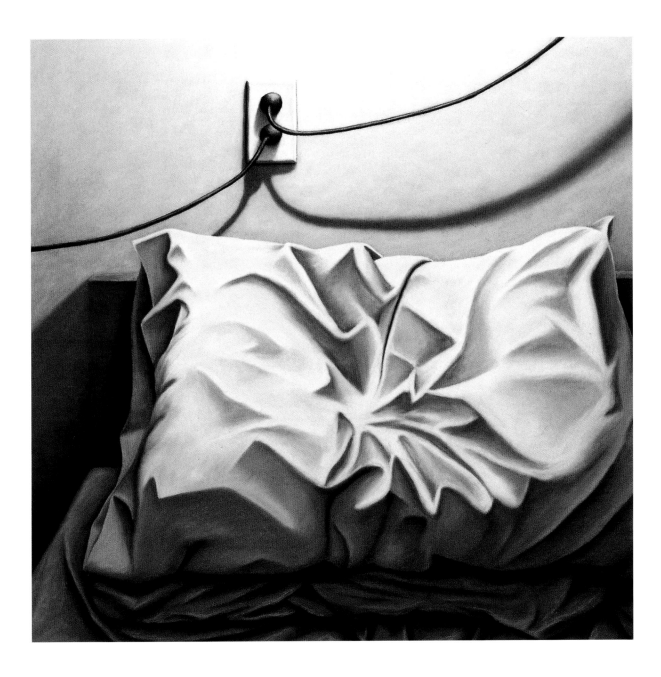

PLATE 47

Alternating Current

1998
Pastel on Paper
26 ½" x 27 ⅜"

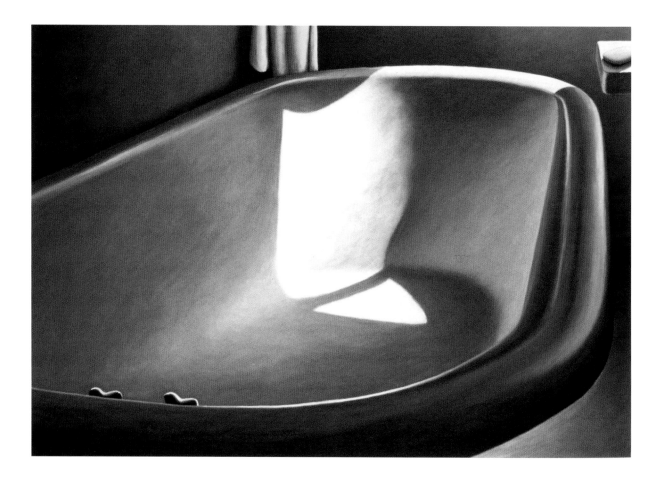

Immersion

1998
Pastel on Paper
26 ½" x 38"

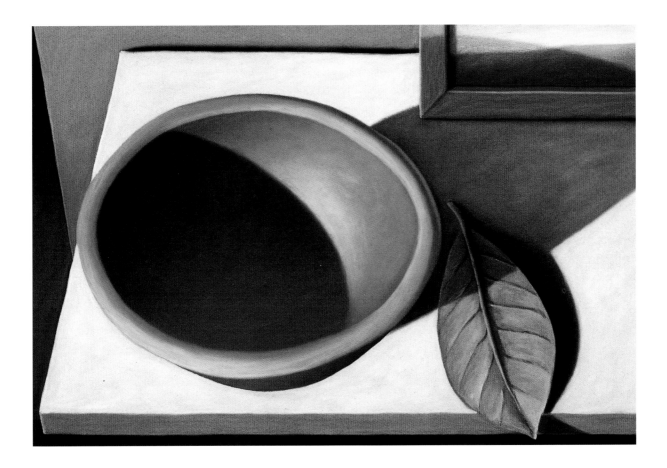

Red Bowl & Landscape

1998
Pastel on Paper
15 ½" x 23"

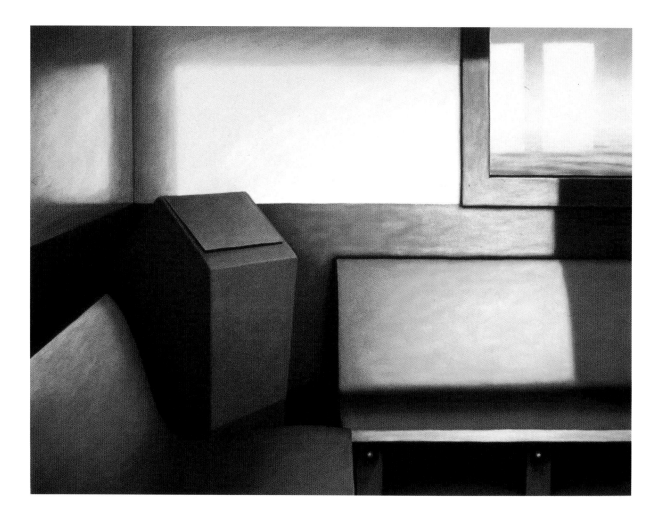

PLATE 50

Wait/Waste

1999
Pastel on Paper
26 ½" x 35 ⅜"

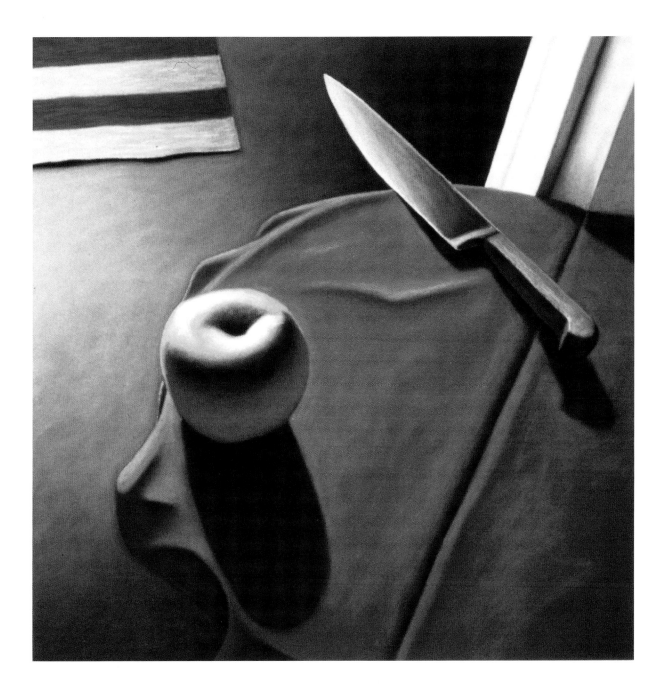

PLATE 51

Delicious

1999
Pastel on Paper
17 ¼" x 17 ¼"

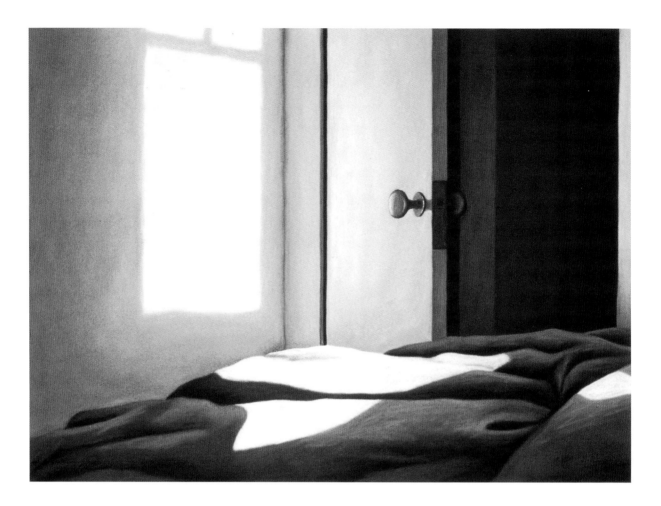

PLATE 52

Bedscape

1999
Pastel on Paper
16 ¾" x 23"

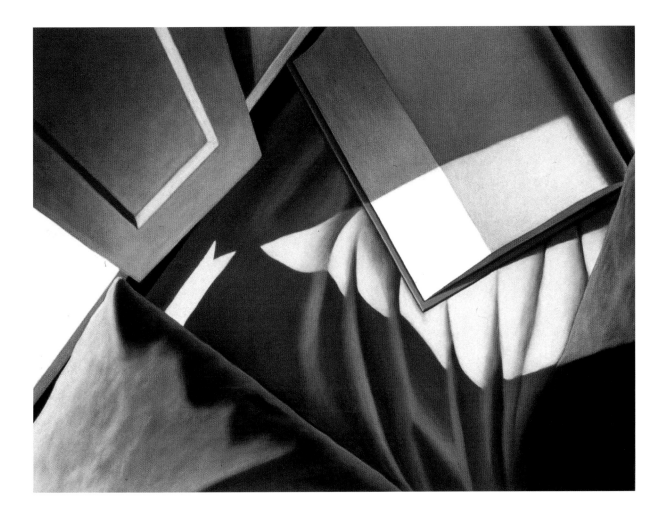

PLATE 53

Page One Thousand

1999
Pastel on Paper
26 ½" x 35 ⅜"

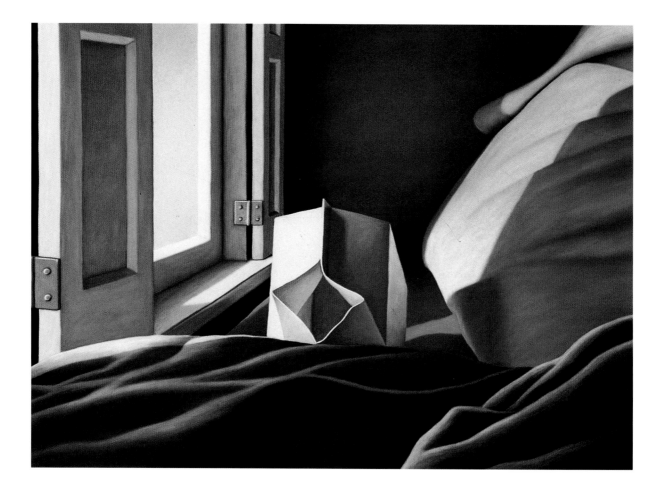

PLATE 54

Pour

1999
Pastel on Paper
26 ½" x 37 ⅛"

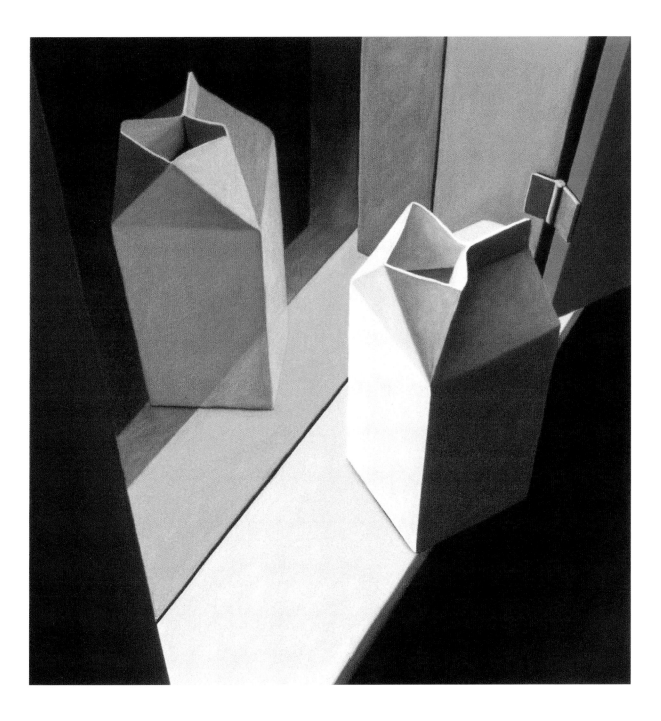

Imbalance

1999
Pastel on Paper
21 ⅝" x 20 ⅝"

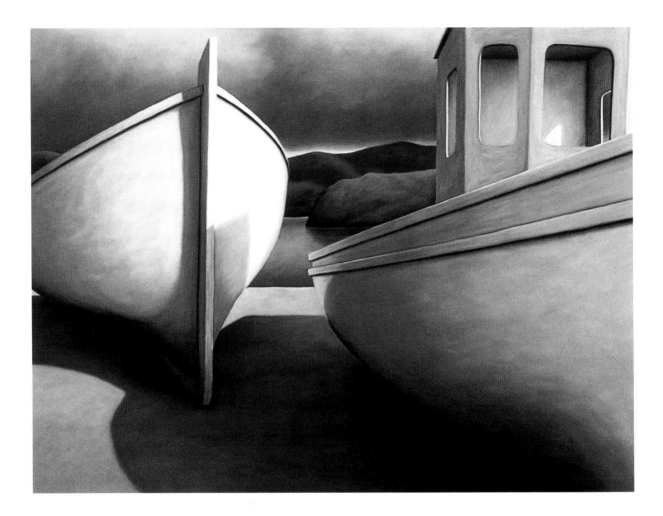

Figment

1998
Pastel on Paper
26 ½" x 35 ⅜"

PLATE 57

The Fiddler's Room

1998
Pastel on Paper
26 ½" x 37 ⅞"

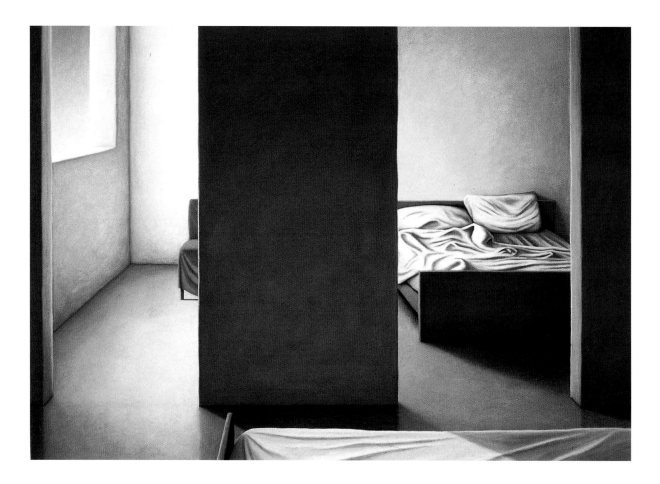

PLATE 58

Witness

1999
Pastel on Paper
26 ½" x 37 ⅝"

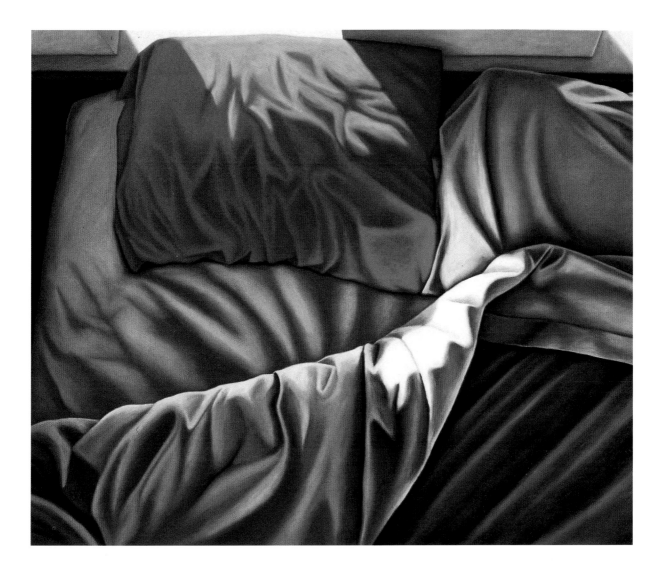

PLATE 59

Without a Map

2000
Pastel on Paper
26 ½" x 32 ⅛"

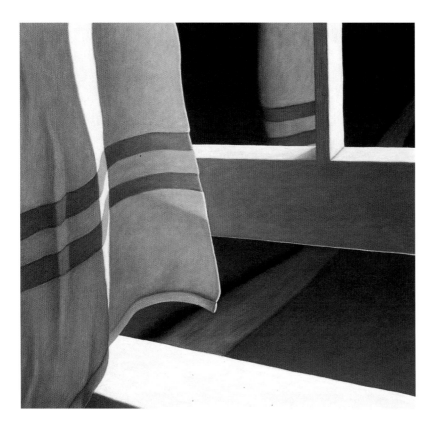

PLATE 60

Flesh

1999
Pastel on Paper
26 ½" x 28 ⅜"

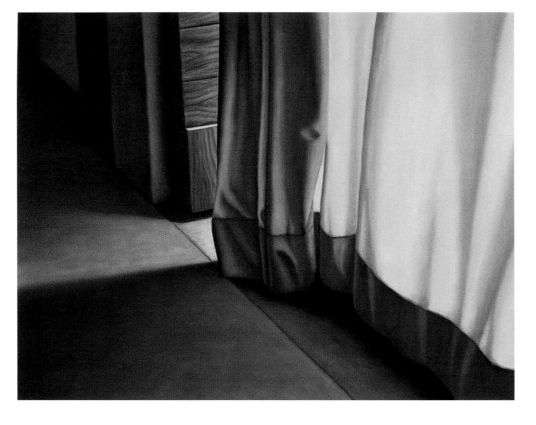

PLATE 61

Scrim

1999
Pastel on Paper
17" x 22 ⅝"

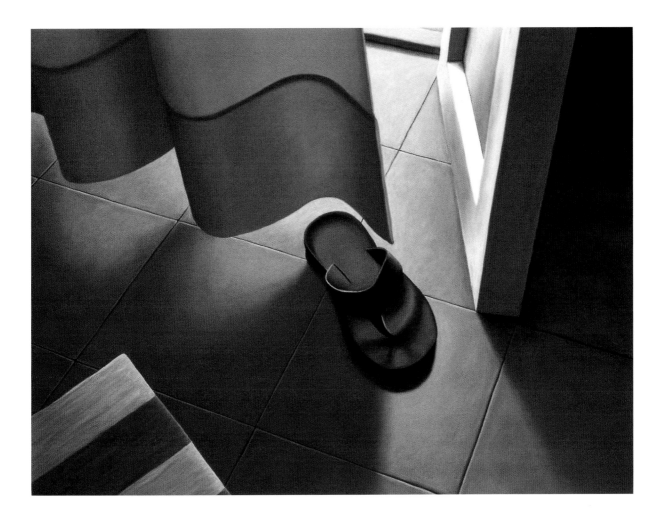

PLATE 62

Flip Flop

2000
Pastel on Paper
26 ½" x 35"

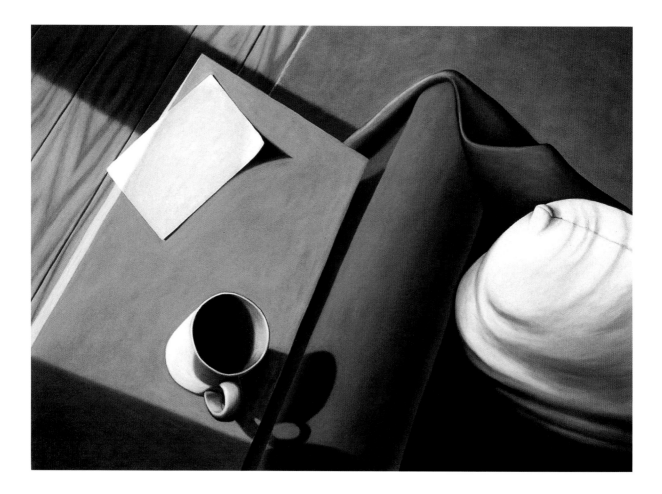

PLATE 63

Writing a Poem

1999
Pastel on Paper
26 ½" x 37 ¼"

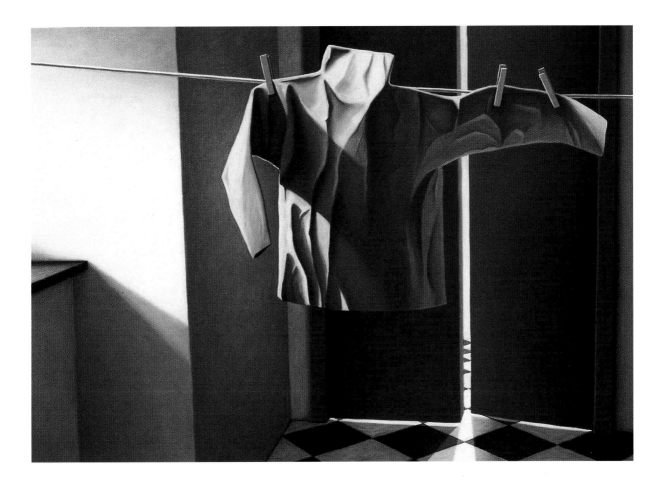

PLATE 64

Paper Shirt

1999
Pastel on Paper
26 ½" x 37 ½"

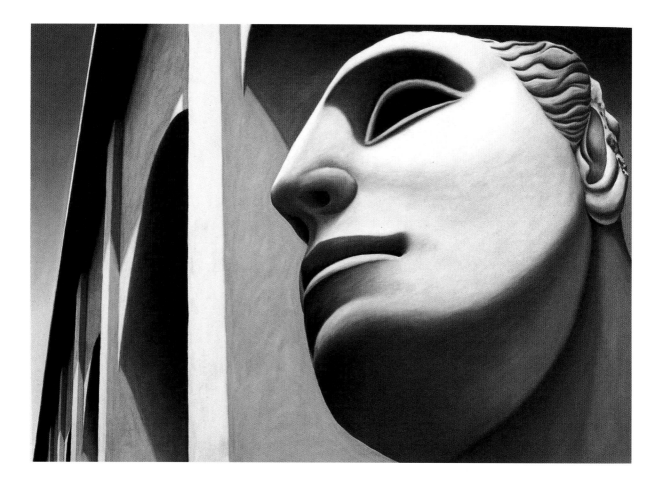

PLATE 65

Blind

2000
Pastel on Paper
26 ½" x 38"

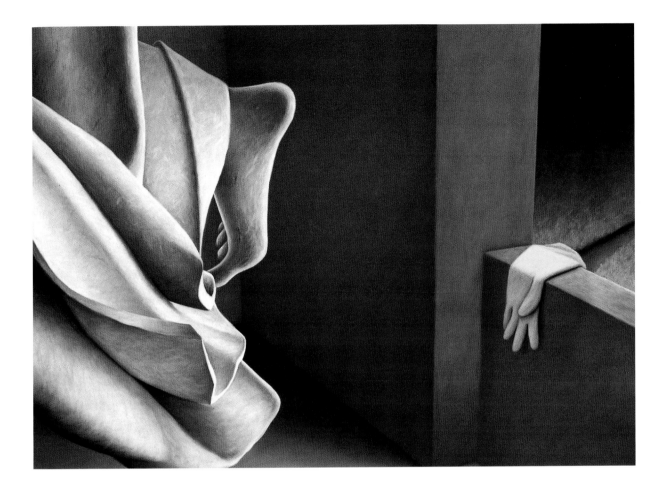

Tempo Perso

1999
Pastel on Paper
26 ½" x 36 ¾"

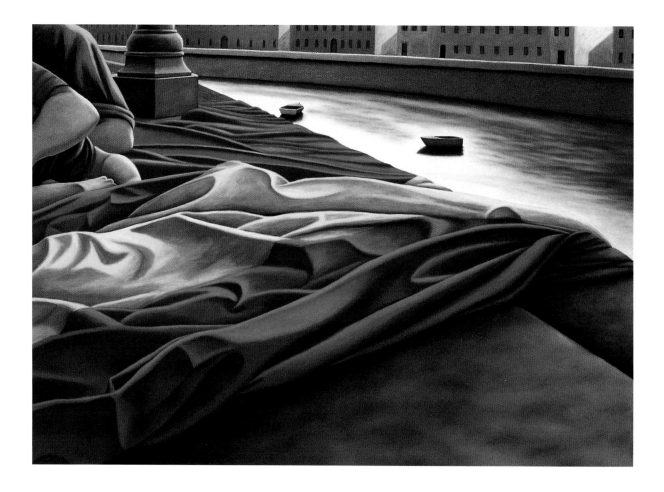

PLATE 67

Regatta

1999
Pastel on Paper
26 ½" x 37 ¼"

Selected Biography

Susan Bennerstrom

Born 1949, Seattle, WA

Education

1968-70
Western Washington University, Bellingham, WA

Teaching

2000
Coupeville Arts Center, Coupeville, WA

1991 to Present
Pratt Fine Arts Center, Seattle

1998
School of Visual Concepts, Seattle

1997
Ballyhugh Art & Culture Centre, County Cavan, Ireland
Knockadoon Centre, County Cork, Ireland

Curating

1999
"From Here to the Horizon: Artists of the Rural Land-
scape," Whatcom Museum of History and Art,
Bellingham, WA

Collections

Whatcom Museum of History and Art, Bellingham, WA
The Microsoft Collection, Redmond, WA
Western Washington University, Bellingham, WA
Skagit Valley College, Mount Vernon, WA
University of Washington Medical Center, Seattle, WA
Wilson Library, Bellingham, WA

Awards

1998
Artist Trust GAP Grant, Seattle, WA

1997
Corporate Council for the Arts, Seattle, WA
Annual Commemorative Poster

1995
Mayor's Art Award, Bellingham, WA

1994
METRO Arts Program, Art/Poetry Bus Project

1992
Artist Trust GAP Grant

1988
Third Annual Northwest Poets and Artists Calendar
Washington Arts Commission *Art in Public Places Program*

1987
Artist Trust Fellowship, Semi-Finalist
Pacific Northwest Arts and Crafts Fair, Juried Exhibition
First Place Award, Drawing
Seattle Art Museum *Betty Bowen Special Recognition Award*

1986
Washington State Arts Commission
Art in Public Places Program

1984
Northwest International Art Competition
Second Place Award

Selected Exhibitions

2000
Davidson Galleries, Seattle, WA, Solo Exhibition

1999
Davidson Galleries, Seattle, WA, Solo Exhibition
Margo Jacobsen Gallery, Portland, OR, Solo Exhibition
J. Cacciola Galleries, New York, NY, Solo Exhibition
Jenkins-Johnson Gallery, San Francisco, CA
 Annual Realism Invitational
Whatcom County Museum, Bellingham, WA
 From Here to the Horizon: Curator's View

1998
Davidson Galleries, Seattle, WA, Solo Exhibition
Washington State Convention Center, Seattle, WA
 Betty Bowen Award 20th Anniversary Exhibition

1997
Davidson Galleries, Seattle, WA, Solo Exhibition
Tacoma Art Museum, Tacoma, WA, *True Art,* Curated
 Exhibition
Ballyhugh Art & Culture Centre and County
 Courthouse Gallery, Cavan, Ireland, Solo Exhibition

1996
Davidson Galleries, Seattle, WA, Solo Exhibition
J. Cacciola Galleries, New York, NY, Solo Exhibition
Museum of Northwest Art, LaConner, WA
 Shaped by the Land, four-person show

1995
Davidson Galleries, Seattle, WA, Solo Exhibition
Fletcher Gallery, Santa Fe, NM, Solo Exhibition
Henry Gallery, University of Washington, Seattle, WA
 Art for the People, Curated Exhibition

1994
Whatcom Museum of History and Art, Bellingham, WA
 Susan Bennerstrom, Solo Exhibition
Davidson Galleries, Seattle, WA, Solo Exhibition

1993
Davidson Galleries, Seattle, WA, Solo Exhibition
Fletcher Gallery, Santa Fe, NM, Solo Exhibition

1992
Davidson Galleries, Seattle, WA, Solo Exhibition
Fletcher Gallery, Santa Fe, NM, Solo Exhibition
Security Pacific Gallery, Seattle, WA, *The Betty Bowen Legacy*

1991
Davidson Galleries, Seattle, WA, Solo Exhibition

Fletcher Gallery, Santa Fe, NM, Solo Exhibition

1990
Port Angeles Fine Art Center, Port Angeles, WA,
 Solo Exhibition

1989
Fletcher Gallery, Santa Fe, NM, Solo Exhibition
Davidson Galleries, Seattle, WA, Solo Exhibition
Alonso/Sullivan Gallery, Seattle, WA, Solo Exhibition
Bellevue Art Museum, Bellevue, WA
 Pacific Northwest, Juried Exhibition

1988
Skagit Valley College, Mount Vernon, WA, Solo Exhibition
Carnegie Art Center, Walla Walla, WA, Solo Exhibition
Pacific Art Center, Seattle, WA, *Art in Nature,* Curated
 Exhibition
Lisa Harris Gallery, Seattle, WA
 Pastels: Landscapes from the Chalk Circle

1987
Alonso/Sullivan Gallery, Seattle, WA, Solo Exhibition
Whatcom Museum of History and Art, Bellingham, WA
 Northwest Landscapes: Bennerstrom, Cole, and Wood
Bellevue Art Museum, Bellevue, WA, *Pacific Northwest,*
 Juried Exhibition

1986
Alonso/Sullivan Gallery, Seattle, WA, Solo Exhibition

1985
Bellevue Art Museum, Bellevue, WA
 Pacific Northwest, Juried Exhibition

1984
Whatcom Museum of History and Art, Bellingham, WA
 Northwest International, Juried Exhibition

1983
Whatcom Museum of History and Art, Bellingham, WA
 Pastel Drawings: Susan Bennerstrom and Thomas Wood
Whatcom Museum of History and Art, Bellingham, WA
 Northwest International, Juried Exhibition

1982
Whatcom Museum of History and Art, Bellingham, WA
 Northwest International, Juried Exhibition

1981
Whatcom Museum of History and Art, Bellingham, WA
 Northwest International, Juried Exhibition

Selected Bibliography

Wesley Pulkka, *Contemporary Realism: A New Twist on Tradition,* Southwest Art, March 2000

*Artists to Watch: Susan Bennerstrom...*Southwest Art, July 1999

Catalogue for Realism Invitational, Jenkins-Johnson Gallery, San Francisco, essay by Peter Frank, June 1999

Margaret Bikman, *Art's Going to the Country: Exhibit Focuses on Rural Landscapes, Themes,* Bellingham Herald, April 23, 1999

Robin Updike, *Shows Worth a Close Look,* (review) Seattle Times, April 8, 1999

Robin Updike, *Landscapes by Lottery – It Keeps the Growing Crowd of Buyers in Line for Bellingham Artist's Work,* Seattle Times, May 27, 1998

Exhibition of Pastels by American Artist Susan Bennerstrom, The Anglo-Celt, Cavan, Ireland, October 9, 1997

Whatcom Places, Introduction by Ivan Doig, Whatcom Land Trust, pub., 1997

Deloris Tarzan Ament, (review) Seattle Sidewalk, April 18, 1997

Ted Lundberg, *Susan Bennerstrom: Pastels,* Preview Magazine, April/May 1996

Creativity in Bloom (review) Seattle Times, April 12, 1996

Sheila Farr, *Retinal Pleasures,* Seattle Weekly, (review) April 17, 1996

Barbara Straker James, *Shaped by the Land,* Museum of Northwest Art News, Summer 1996

Carmi Weingrod, *Art by Census: Should People Get Exactly What They Ask For?* American Artist, October 1995

Gussie Fauntleroy, *Travelling to the Edge of Expectation,* The Santa Fe New Mexican, August 25, 1995

Bruce Barcott, *Art Your Way,* Seattle Weekly, April 6, 1995

Sheila Farr, *America's Most Wanted,* Bellingham Herald, April 22, 1995

The Bellingham Review, (image), vol. 17, nos. 1 & 2, 1994

Willow Springs, (images), no. 34, Summer 1994

Nature Through Her Eyes: Art and Literature by Women, Edited by Mary Bemis and Belinda Recio, published by The Nature Company, 1994

Sheila Farr, *Light on the Landscape,* (review), Bellingham Herald, July 23, 1994

Susan Bennerstrom, Artist of the Ominous, The World and I Magazine, vol. 9, no. 1, January 1994

Deloris Tarzan Ament, review, Seattle Times, April 26, 1993

Candelora Versace, *Brooding Hills, Sunny Shores: A Study in Contradiction,* The Santa Fe New Mexican, August 7, 1992

Jessica Maxwell, *Palouse Pentimento,* Pacific Northwest Magazine, April 1992

Russ Whiting, *Bennerstrom Moves at Her Own Pace,* Santa Fe New Mexican, August 9, 1991

Karen Matheison, review, Seattle Times, March 7, 1991

John Marshall, *Visions of Success,* Seattle P-I, June 3, 1991

Ann Douglas, After, (book cover), published Breitenbush Books, Portland, 1989

Artweek, (review), January 14, 1989

John Harris, *Artist Tries Change of Pace,* Bellingham Herald, January 10, 1989

Acknowledgements

To the patrons of this project, thank you for your generous support, without which this book would not have been possible. Special thanks to Sarah Clark-Langager, Rod Slemmons and Robin Updike for their insightful essays; to Sam Davidson and Scott Lawrimore of Davidson Galleries and to Joseph Gagnon for the book design; to Elizabeth Tapper, master printmaker; and to my husband, C.A. Scott, and my dad and stepmother, Jake and Marni Rankin, for all their support. *S.B.*

Patrons

Marian Alexander & David Netboy M.D.
Eileen Bruce & Chris Rennick
Ann L. Darling
Elizabeth H. D. Davidson
Janeen Jenkins
Jerry & Marian Krell
Bradford Lovering & Valerie Baker
James & Lori Mueller
Clint & Maggie Pehrson
Dave & Susan Peterson
Jake & Marni Rankin
Sue & Alan M. Silberstein
Lori & Evan Stone
Barbara Szudy & Graham Bird

Photography Credits

Rod Burton
Peter Kobzan
Dana Moody
Rodrigo del Pozo